LETTERHEAD & LOGO DESIGN 7

First published in the United States of America by
Rockport Publishers, Inc.
33 Commercial Street
Gloucester, Massachusetts 01930-5089
Telephone: (978) 282-9590
Fax: (978) 283-2742
www.rockpub.com

ISBN 1-56496-980-0

10 9 8 7 6 5 4 3 2 1

Design: Sayles Graphic Design
Cover Image: John Sayles

Printed in China

CONTENTS

INTRODUCTION

The ability to grab, express, stimulate, push, provoke, blow. . .not really words you'd use to describe your corporate identity. But we think they describe some of the latest and most innovative letterhead and logo designs in use today. These designs grab attention, express a message, stimulate interest, push a product, provoke a response, and blow the competition out of the water!

Today's best designers are creating logo and letterhead designs that communicate their message with bold graphics, unexpected textures, brilliant colors, and special effects. Judicious use of these element differentiates a good logo or letterhead system from a great one—and the truly great ones have the added ability to convey the clients' organizational personality at a glance.

The best way a logo or letterhead design can successfully communicate a company's message is with versatility. A good logo must be effective in one or multiple colors and able to appear in numerous sizes and in a variety of media. It may simultaneously need to be clear on a fax, small on a business card, huge on a billboard, and digital on a website.

Works selected for *Letterhead and Logo Design 7* represent 12 countries and more than 70 design firms. We'd like to acknowledge the enthusiasm and participation of design firms worldwide. The staff of Sayles Graphic Design was pleased to jury more than 1,500 entries; a three-day staff retreat was devoted to the selection process. The 200+ projects appearing in this book include fresh designs, striking illustrations, and clever executions. They are intended to inspire you to design logo and letterhead systems that creatively and effectively get the job done. Enjoy!

-John Sayles, Sheree Clark, and the staff of Sayles Graphic Design

ABOUT THE
AUTHOR

John Sayles worked for two Des Moines, Iowa advertising agencies before starting his own freelance business in 1983. In 1985, John met Sheree Clark, then an administrator and John's client at Drake University in Des Moines. Six months and one successful design project later, Sayles Graphic Design opened in downtown Des Moines.

Today, Sayles Graphic Design has a staff of six and clients around the globe in nearly every type of service and industry. A simple philosophy--Creativity, Consistency, and Honesty--and an unassuming approach to business allow each staff member to do what they do best, whether it's design or marketing or client service. As a result, design and strategy go hand-in-hand on every project.

Since establishing the firm, Sayles Graphic Design has developed more than 500 logos and icons and nearly 200 letterhead programs, in addition to projects involving packaging, direct mail, collateral, and environments. John's bold style and use of non-traditional materials has made the firm's work known worldwide. Sayles Graphic Design has become a common name in local and international design publications, a frequent award-winner from organizations around the world, and an authority on such topics as creative direct mail design, design with non-traditional materials, and self-promotion. Sayles Graphic Design's work is also included in the permanent collections of the Smithsonian Institution's National Design Museum and the Library of Congress.

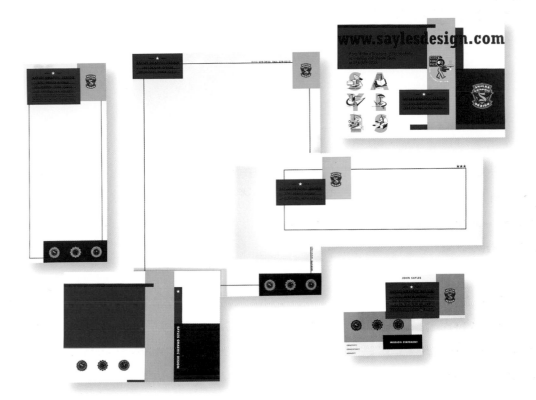

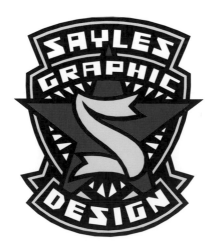

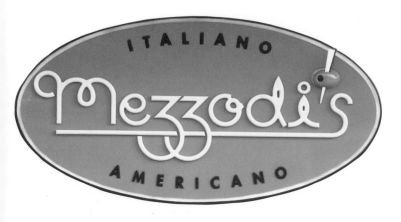

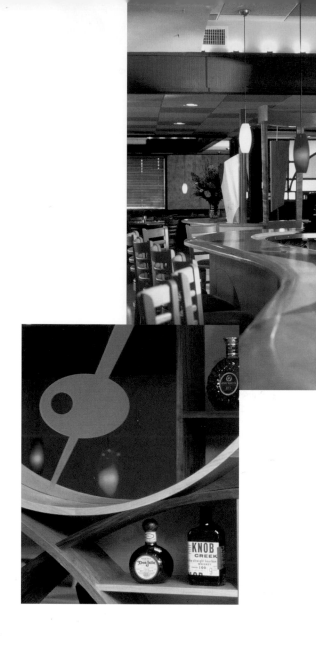

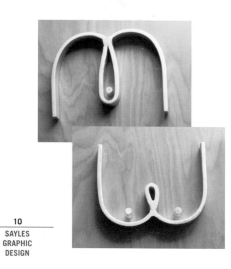

CLIENT | Mezzodi's Restaurant

CLIENT | American Cancer Society

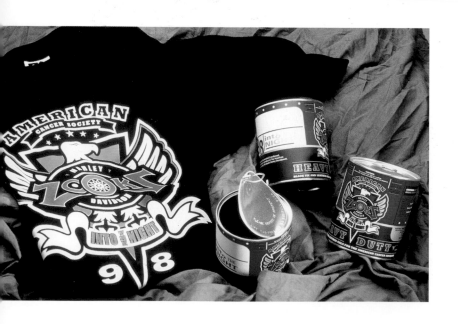

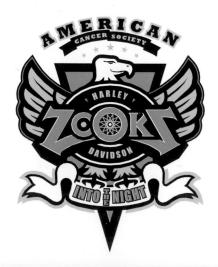

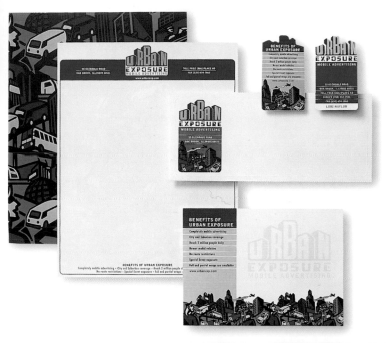

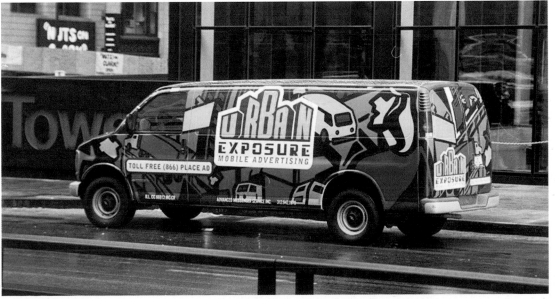

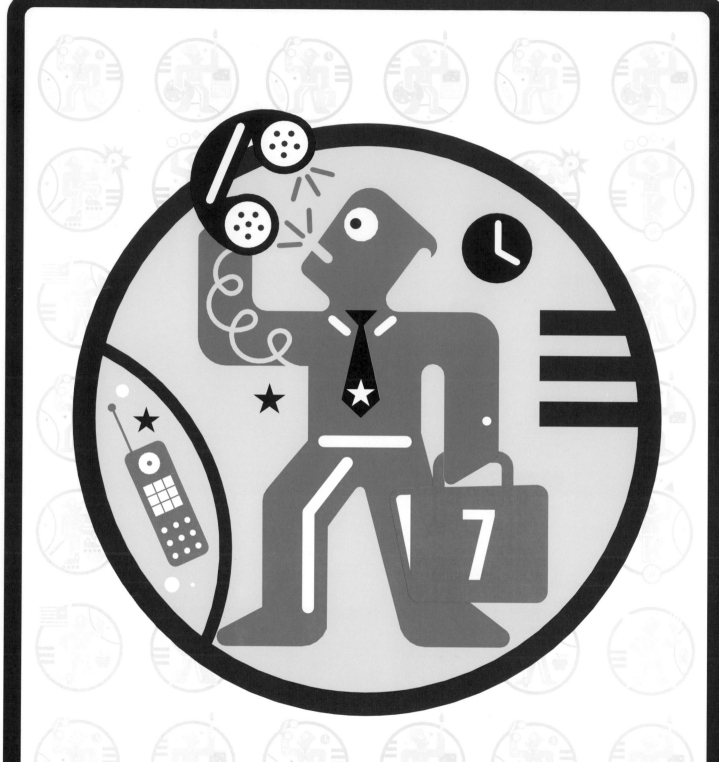

PROFESSIONAL SERVICES

DESIGN FIRM | A1 Design
DESIGNER | Amy Gregg
CLIENT | Sandglass
TOOLS | Adobe Illustrator, Macintosh

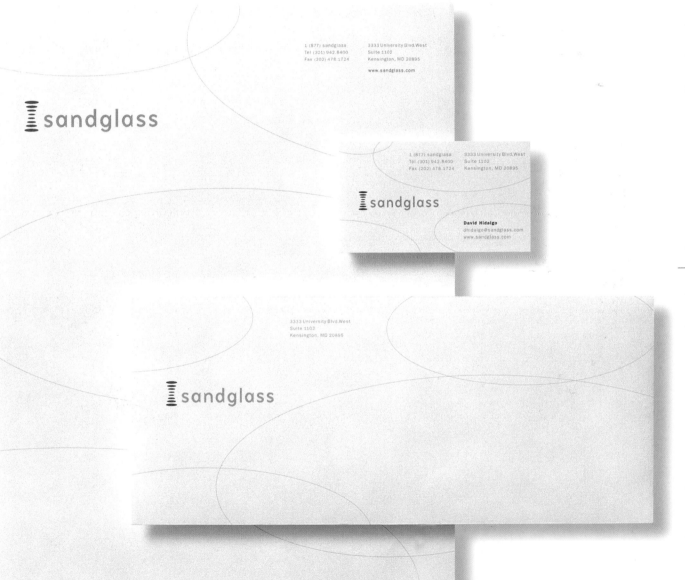

RED WHISTLE
COMMUNICATIONS

KARIN HESSELVIK
ACCOUNT ASSOCIATE
KHESSELVIK@REDWHISTLE.COM

DIRECT 415.616.6221
MAIN 415.616.6140
FAX 415.616.6122
201 CALIFORNIA STREET
SAN FRANCISCO, CA 94111

A WEBER WORLDWIDE COMPANY

WWW.REDWHISTLE.COM

RED WHISTLE
COMMUNICATIONS

201 CALIFORNIA STREET SAN FRANCISCO, CA 94111

49 STEVENSON STREET SAN FRANCISCO, CA 94105 TEL 415.512.4900 FAX 415.975.9930
WWW.REDWHISTLE.COM
A WEBER SHANDWICK WORLDWIDE COMPANY

DESIGN FIRM	A1 Design
DESIGNER	Amy Gregg
CLIENT	Red Whistle
TOOLS	Adobe Illustrator, Macintosh

DESIGN FIRM	A1 Design
ART DIRECTOR	Amy Gregg
DESIGNER	Qui Tong
CLIENT	Aberdare Ventures
TOOLS	Adobe Illustrator, Macintosh

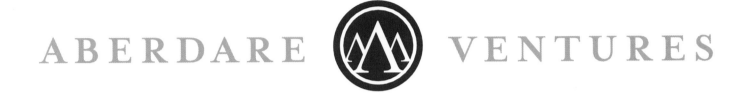

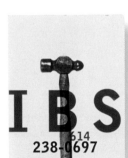

IBS
614
238-0697

IBS
614
238-0697

IBS
614
238-0697

DENISE BRIDGETTE HASHEMI

OPERATIONS/DESIGN

IBS

INTEGRATED BUILDING SERVICES

2513 EAST MAIN STREET, SUITE C

BEXLEY, OHIO 43209

614.238.0697 T 614.238.0735 F

614.206.5455 MOBILE

ERIC VACHERESSE

SUPERINTENDENT

IBS

INTEGRATED BUILDING SERVICES

2513 EAST MAIN STREET, SUITE C

BEXLEY, OHIO 43209

614.238.0697 T 614.238.0735 F

614.206.4389 MOBILE

RICHARD WALLACH

PRESIDENT

IBS

INTEGRATED BUILDING SERVICES

2513 EAST MAIN STREET, SUITE C

BEXLEY, OHIO 43209

614.238.0697 T 614.238.0735 F

614.206.4387 MOBILE

DESIGN FIRM	Base Art Co.
ART DIRECTOR	Terry Alan Rohrbach
DESIGNER	Terry Alan Rohrbach
CLIENT	Integrated Business Solutions
TOOLS	Macromedia FreeHand, Macintosh

DESIGN FIRM	Buchanan Design
ART DIRECTOR	Bobby Buchanan
DESIGNER	Bobby Buchanan
CLIENT	Davinci by Design
TOOLS	Adobe Illustrator, Macintosh

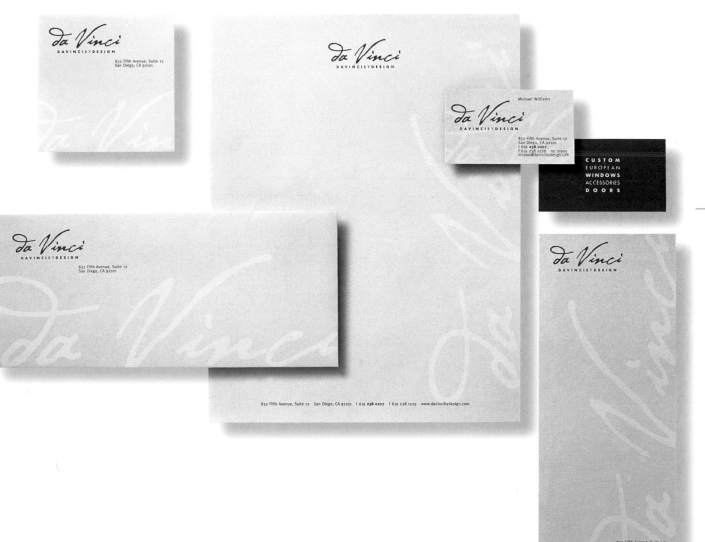

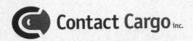 Contact Cargo inc.

 Contact Cargo inc.

769, Stuart Graham Nord, bureau 131
Dorval (Québec) H4Y 1E7

Denis Trottier
Directeur général
General Manager

 Contact Cargo inc.

765, Stuart Graham Nord, bureau 50
Dorval (Québec) H4Y 1E6

Tél.: (514) 636-7007
Fax: (514) 636-2100

769, Stuart Graham Nord, bureau 131, Dorval (Québec) H4Y 1E7 Tél.: (514) 636-1551 • Fax: (514) 636-9573

STONITSCH
CONSTRUCTION

GENERAL CONTRACTING DESIGN/BUILD CONSTRUCTION MANAGEMENT

STONITSCH
CONSTRUCTION

GENERAL CONTRACTING DESIGN/BUILD
CONSTRUCTION MANAGEMENT

RONALD J. STONITSCH
PRESIDENT

409 W. JEFFERSON STREET JOLIET, ILLINOIS 60435
TEL: 815.723.2233 FAX: 815.723.2171
www.stonitsch.com e-mail: rstonitsch@stonitsch.com

409 W. JEFFERSON STREET JOLIET, ILLINOIS 60435 TEL: 815.723.2233 FAX: 815.723.2171
visit us at: www.stonitsch.com

DESIGN FIRM	Bullet Communications, Inc.
ART DIRECTOR	Timothy Scott Kump
DESIGNER	Timothy Scott Kump
CLIENT	Stonitsch Construction
TOOLS	Quark XPress, Macintosh

DESIGN FIRM	Beaulieu Concepts Graphiques, Inc.
ART DIRECTOR	Gilles Beaulieu
DESIGNER	Gilles Beaulieu
CLIENT	Contact Cargo
TOOLS	Adobe Illustrator, Macintosh

lasertek

DESIGN FIRM	cincodemayo
ART DIRECTOR	Mauricìo Alanis
DESIGNER	Mauricìo Alanis
CLIENT	Lasertek
TOOLS	Macromedia FreeHand, Macintosh

DESIGN FIRM	Christopher Gorz Design
ART DIRECTOR	Chris Gorz
DESIGNER	Chris Gorz
CLIENT	Scubalogy
TOOLS	Adobe Illustrator, Macintosh

Basic, Advanced & Specialty SCUBA Instruction

DESIGN FIRM	Christopher Gorz Design
ART DIRECTOR	Chris Gorz
DESIGNER	Chris Gorz
CLIENT	EnvestNet
TOOLS	Adobe Illustrator, Macintosh

PRINCETON
REIMBURSEMENT
GROUP

DESIGN FIRM	Design Center
ART DIRECTOR	John Reger
DESIGNER	Sherwin Schwartzrock
CLIENT	Princeton Reimbursement Group
TOOLS	Macromedia FreeHand, Macintosh

CoreVISION

DESIGN FIRM	Design Center
ART DIRECTOR	John Reger
DESIGNER	Sherwin Schwartzrock
CLIENT	Core Vision
TOOLS	Macromedia FreeHand, Macintosh

DESIGN FIRM	Design Center
ART DIRECTOR	John Reger
DESIGNER	Sherwin Schwartzrock
CLIENT	Market Trust
TOOLS	Macromedia FreeHand, Macintosh

MARKETTRUST

DESIGN FIRM	D4 Creative Group
ART DIRECTOR	Wicky W. Lee
DESIGNER	Wicky W. Lee
CLIENT	Ajunto
TOOLS	Adobe Illustrator, Quark XPress, Macintosh G4

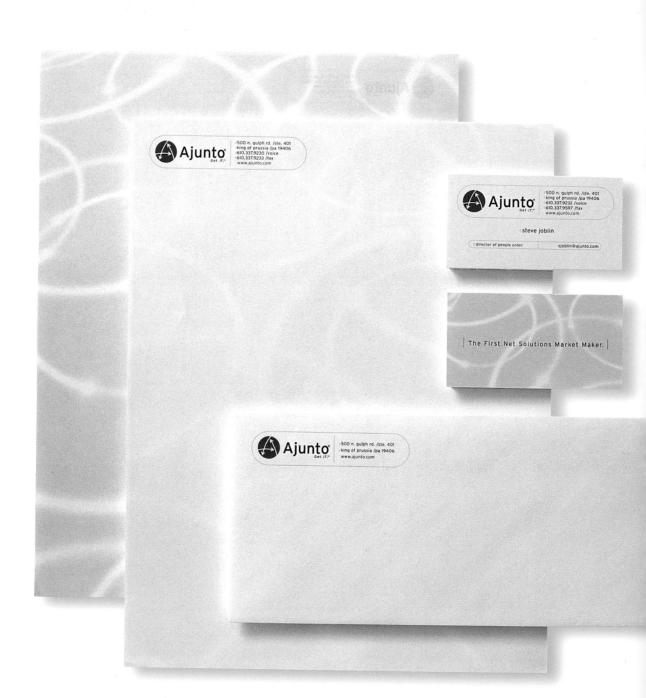

DESIGN FIRM | DogStar
ART DIRECTOR | Clyde Goode/HSR Business to Business
DESIGNER | Rodney Davidson
CLIENT | spotlightsolutions.com
TOOL | Macromedia FreeHand 7

DESIGN FIRM	DogStar
ART DIRECTOR	Mike Rapp/Gear
DESIGNER	Rodney Davidson
CLIENT	Waterbrook Press (Fisherman Bible Study Series)
TOOL	Macromedia FreeHand 7

DESIGN FIRM | Drive Communications
ART DIRECTOR | Michael Graziolo
DESIGNER | Michael Graziolo
CLIENT | Vuepoint, Corp.
TOOLS | Adobe Illustrator 8.0, Quark XPress 4.1, Macintosh

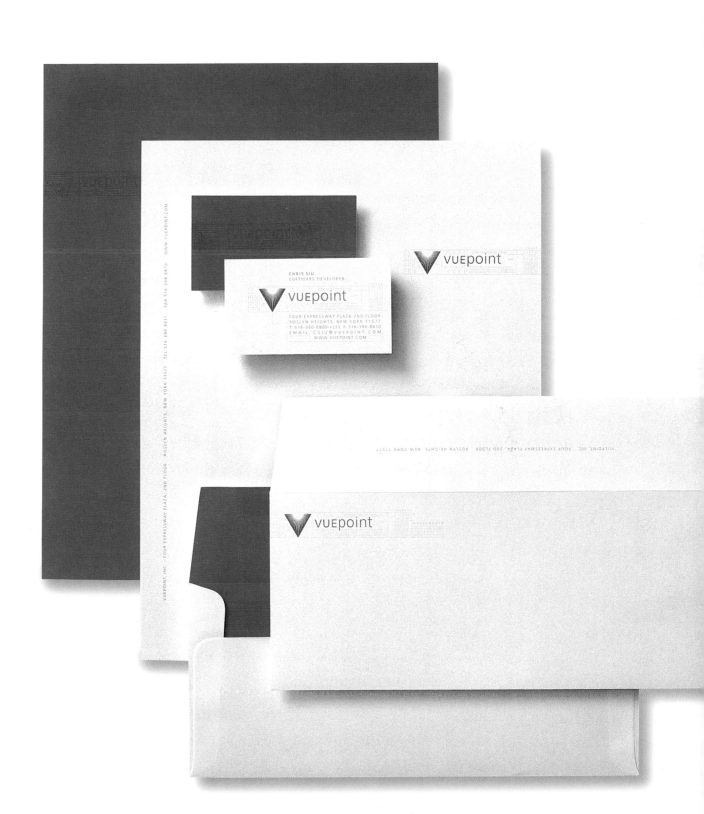

DERRINSTOWN STUD

DERRINSTOWN STUD
Maynooth, County Kildare, Ireland Telephone +353 (0) 1 6286228 Facsimile +353 (0) 1 6286733 www.derrinstown.com
Hubie de Burgh GENERAL MANAGER Stephen Collins MANAGER

DERRINSTOWN
STUD

DESIGN FIRM	e-xentric (UK) Ltd
ART DIRECTOR	Ian McAllister
DESIGNER	Mandi Smith
CLIENT	Derrinstown Stud Farm
TOOLS	Adobe Illustrator, Macromedia FreeHand, Quark Xpress

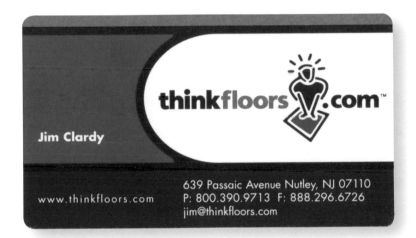

Jim Clardy

thinkfloors.com™

www.thinkfloors.com

639 Passaic Avenue Nutley, NJ 07110
P: 800.390.9713 F: 888.296.6726
jim@thinkfloors.com

DESIGN FIRM	Fuel Creative
ART DIRECTOR	Eric B. Whitlock
DESIGNER	Eric B. Whitlock
CLIENT	Think Floors
TOOL	Adobe Illustrator

CASTILE
VENTURES

DESIGN FIRM	Gee + Chung Design
ART DIRECTOR	Earl Gee
DESIGNER	Earl Gee
CLIENT	Castile Ventures
TOOLS	Adobe Illustrator, Quark XPress

PARTECH

INTERNATIONAL

DESIGN FIRM	Gee + Chung Design
ART DIRECTORS	Earl Gee, Fani Chung
DESIGNERS	Earl Gee, Fani Chung
CLIENT	Partech International
TOOLS	Adobe Illustrator, Quark Xpress

DESIGN FIRM | Gee + Chung Design
ART DIRECTOR | Earl Gee
DESIGNERS | Earl Gee, Kay Wu
CLIENT | Netigy Corporation
TOOLS | Adobe Illustrator, Quark Xpress

NetigySM

DESIGN FIRM	Graphiculture
ART DIRECTOR	Beth Mueller
DESIGNER	Beth Mueller
CLIENT	Targert Corporation
TOOL	Quark XPress

DESIGN FIRM	Gardner Design
ART DIRECTOR	Bill Gardner
DESIGNER	Bill Gardner
CLIENT	Buzz Cuts Maximum Lawncare
TOOL	Macromedia FreeHand

DESIGN FIRM	Gardner Design
ART DIRECTOR	Travis Brown
DESIGNER	Travis Brown
CLIENT	Donovan Transit
TOOL	Macromedia FreeHand

RICHARD C. HITE
RICHARD L. HONEYMAN
RANDY J. TROUTT
ARTHUR S. CHALMERS
KIM R. MARTENS
LINDA S. PARKS
F. JAMES ROBINSON, JR.
DON D. GRIBBLE, II
DENNIS V. LACEY
LISA A. MCPHERSON

HITE
FANNING &
HONEYMAN L.L.P.
ATTORNEYS AT LAW

JERRY D. HAWKINS
JON E. NEWMAN
SCOTT R. SCHILLINGS
RICHARD D. CROWDER

OF COUNSEL
H.W. FANNING
VINCE P. WHEELER

HITE
FANNING &
HONEYMAN L.L.P.
ATTORNEYS AT LAW

SUITE 600 ▪ 200 WEST DOUGLAS AVE.
WICHITA, KANSAS ▪ 67202 3089

HITE
FANNING &
HONEYMAN L.L.P.
ATTORNEYS AT LAW

A. KAY DAVIS
LEGAL ASSISTANT

SUITE 600
200 WEST DOUGLAS AVE.
WICHITA, KS ▪ 67202 3089
TELEPHONE ▪ 316 265 7741
FACSIMILE ▪ 316 267 7803
DAVIS@HITEFANNING.COM

SUITE 600 ▪ 200 WEST DOUGLAS AVE. ▪ WICHITA, KANSAS ▪ 67202 3089
TELEPHONE 316 265 7741 ▪ FACSIMILE 316 267 7803

DESIGN FIRM	Hornall Anderson Design Works, Inc.
ART DIRECTOR	Jack Anderson
DESIGNERS	Kathy Saito, Gretchen Cook, James Tee, Julie Lock, Henry Yiu, Alan Copeland, Sonja Max
CLIENT	Gettuit.com
TOOL	Macromedia FreeHand

gettuit.com™

DESIGN FIRM	Gardner Design
ART DIRECTOR	Bill Gardner
DESIGNER	Chris Parks
CLIENT	Hite Fanning & Honeyman L.L.P.
TOOL	Macromedia FreeHand 8

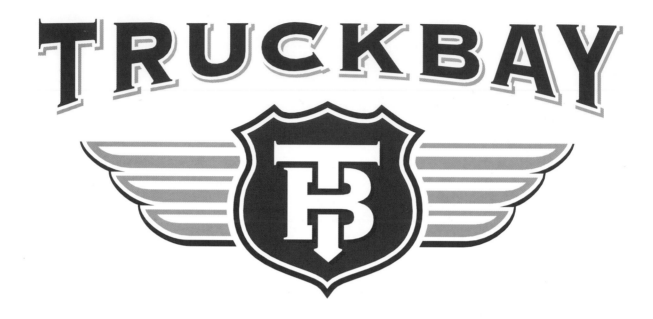

DESIGN FIRM	Hornall Anderson Design Works, Inc.
ART DIRECTORS	Jack Anderson, Debra McCloskey
DESIGNERS	Jack Anderson, Debra McCloskey, John Anderle, Andrew Wicklund
CLIENT	Truck Bay
TOOL	Adobe Illustrator

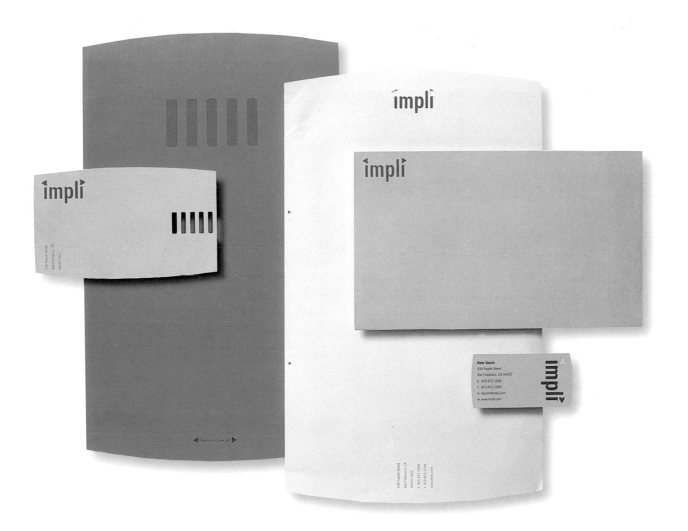

DESIGN FIRM	Hornall Anderson Design Works, Inc.
ART DIRECTOR	Jack Anderson
DESIGNERS	Jack Anderson, Sonja Max, Kathy Saito, Alan Copeland
CLIENT	Impli Corporation
TOOL	Macromedia FreeHand

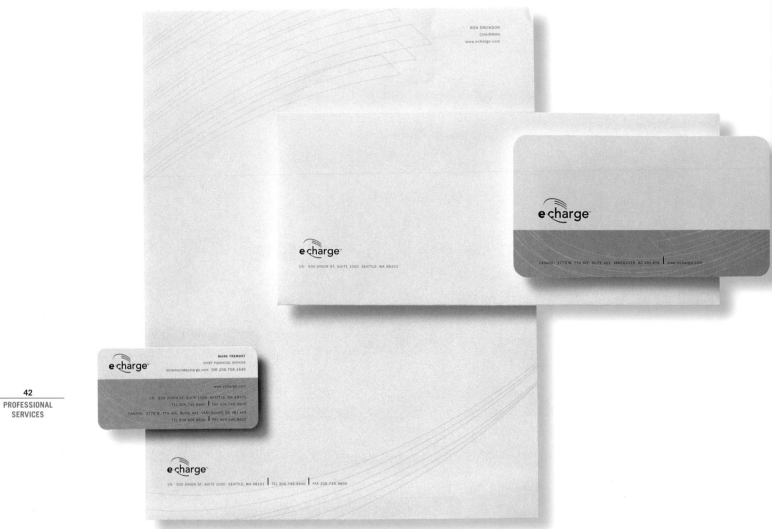

DESIGN FIRM	Hornall Anderson Design Works, Inc.
ART DIRECTOR	Jack Anderson
DESIGNERS	Jack Anderson, Debra McCloskey, Kathy Saito, Holly Craven, Alan Copeland, Gretchen Cook, Henry Yiu
CLIENT	echarge
TOOL	Macromedia FreeHand

DESIGN FIRM	Hornall Anderson Design Works, Inc.
ART DIRECTOR	Jack Anderson
DESIGNERS	Jack Anderson, Katha Dalton, Gretchen Cook, Alan Florsheim, Andrew Smith, Ed Lee
CLIENT	epods
TOOLS	Macromedia FreeHand, Adobe Illustrator

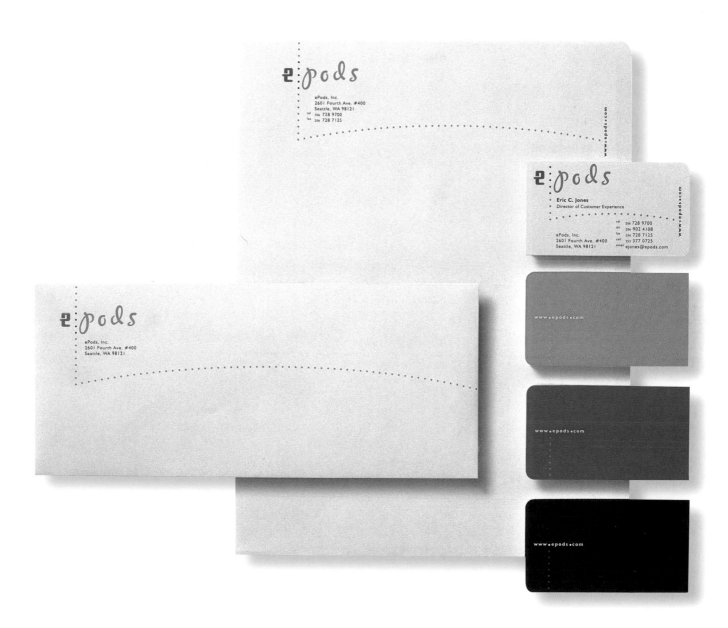

DESIGN FIRM	Hornall Anderson Design Works, Inc.
ART DIRECTOR	Jack Anderson
DESIGNERS	Jack Anderson, Bruce Stigler, James Tee, Henry Yiu
CLIENT	Javelin
TOOL	Macromedia FreeHand

DESIGN FIRM	Insight Design Communications
ART DIRECTORS	Sherrie & Tracy Holdeman
DESIGNERS	Sherrie & Tracy Holdeman
CLIENT	ironweed strategy
TOOL	Macromedia FreeHand 9.0.1

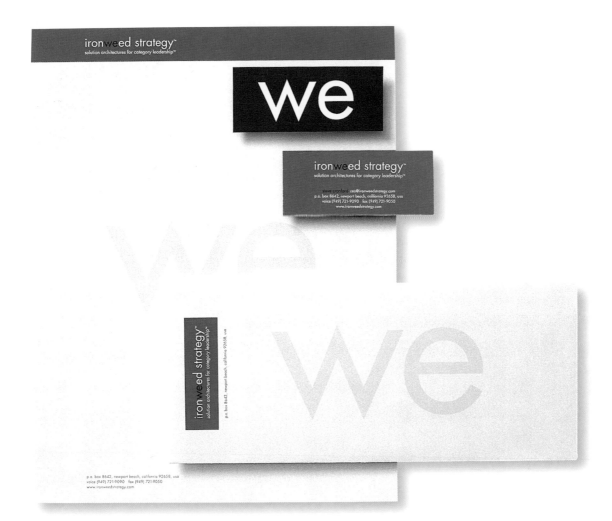

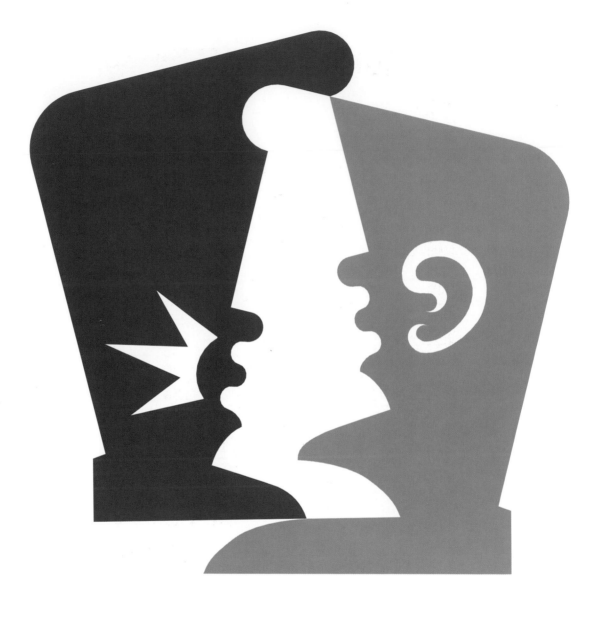

DESIGN FIRM	Insight Design Communications
ART DIRECTORS	Sherrie & Tracy Holdeman
DESIGNERS	Sherrie & Tracy Holdeman
CLIENT	CallSmart
TOOLS	Macromedia FreeHand 9.0.1

DESIGN FIRM	Insight Design Communications
ART DIRECTORS	Sherrie & Tracy Holdeman
DESIGNERS	Sherrie & Tracy Holdeman
CLIENT	Face to Face
TOOL	Hand Drawn, Macromedia FreeHand 9.0.1

DESIGN FIRM | I. Paris Design
ART DIRECTOR | Isaac Paris
DESIGNER | Isaac Paris
CLIENT | TOKYO Wireless
TOOL | Adobe Illustrator 8

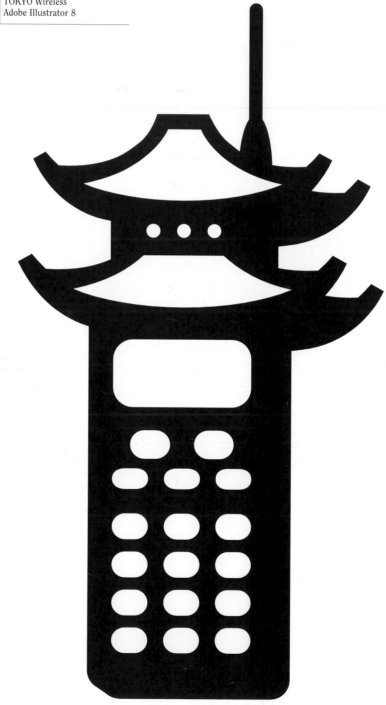

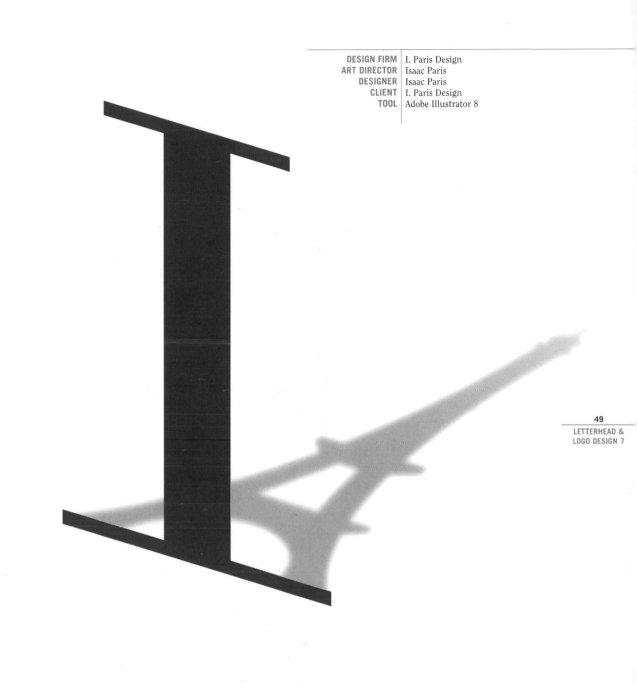

DESIGN FIRM	I. Paris Design
ART DIRECTOR	Isaac Paris
DESIGNER	Isaac Paris
CLIENT	I. Paris Design
TOOL	Adobe Illustrator 8

DESIGN FIRM | Jay Smith Design
ART DIRECTOR | Jay Smith
DESIGNER | Jay Smith
CLIENT | 3 Guys and a Mower
TOOLS | Adobe Illustrator, Macintosh

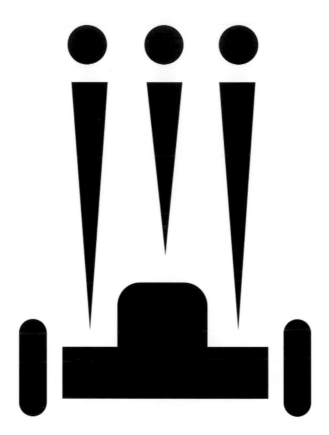

Suite 220 13155 Delf Place Richmond BC Canada V6V 2A2 tel 604.270.4300 fax 604.270.4304 www.cellexpower.com

◄❖► **CELLEX**POWER™

◄❖► **CELLEX**POWER™

Rasvan Mihai Ph.D.
Senior Electrical Engineer

◄❖► **CELLEX**POWER™ Cellex Power Products Inc.
Suite 220 13155 Delf Place
Richmond BC Canada V6V 2A2
www.cellexpower.com

dir 604.248.3550 tel 604.270.4300
cell 604.318.7314 fax 604.270.4304
email rmihai@cellexpower.com

the new power

DESIGN FIRM	Karacters Design Group
ART DIRECTOR	Roy White
DESIGNER	Nancy Wu
CLIENT	Cellex Power
TOOL	Adobe Illustrator

BROWN SHOE

DESIGN FIRM	Kiku Obata & Company
DESIGNERS	Scott Gericke, Amy Knopf, Joe Floresca, Jennifer Baldwin
CLIENT	Brown Shoe Company
TOOLS	Macromedia FreeHand, Macintosh

DESIGN FIRM | Likovni Studio D.O.O.
ART DIRECTOR | Tomislav Mrcic
DESIGNER | Danko Jaksic
CLIENT | Gallus Wines
TOOLS | Macromedia FreeHand, Macintosh

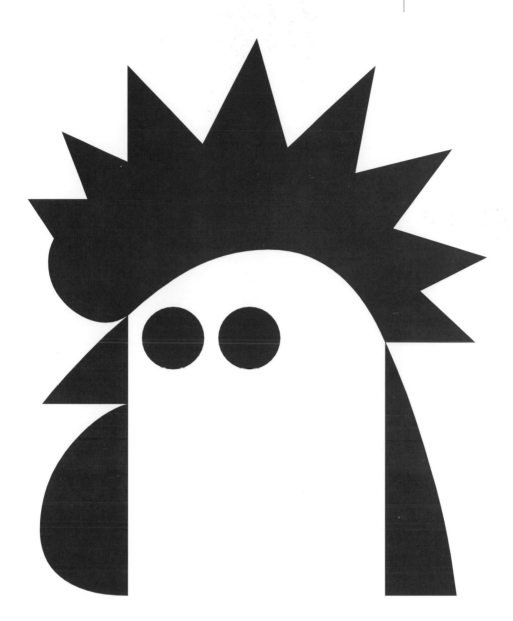

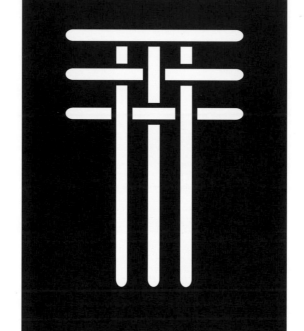

TEXERE

DESIGN FIRM | Mastandrea Design, Inc.
DESIGNER | Maryanne Mastandrea
CLIENT | Texere
TOOLS | Adobe Illustrator, Macintosh

DESIGN FIRM	Energy Energy Design
ART DIRECTOR	Leslie Guidice
DESIGNER	Jeanette Aramburu
CLIENT	Mucho.com
TOOLS	Adobe Illustrator, Macintosh

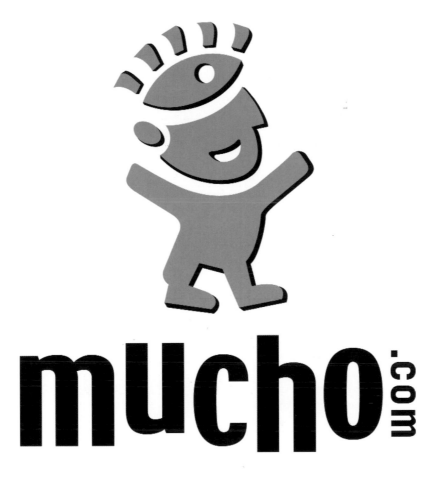

DESIGN FIRM	Energy Energy Design
ART DIRECTOR	Leslie Guidice
SENIOR DESIGNERS	Stacy Guidice, Jeanette Aramburu
CLIENT	StaffBridge
TOOLS	Adobe Illustrator, Macintosh

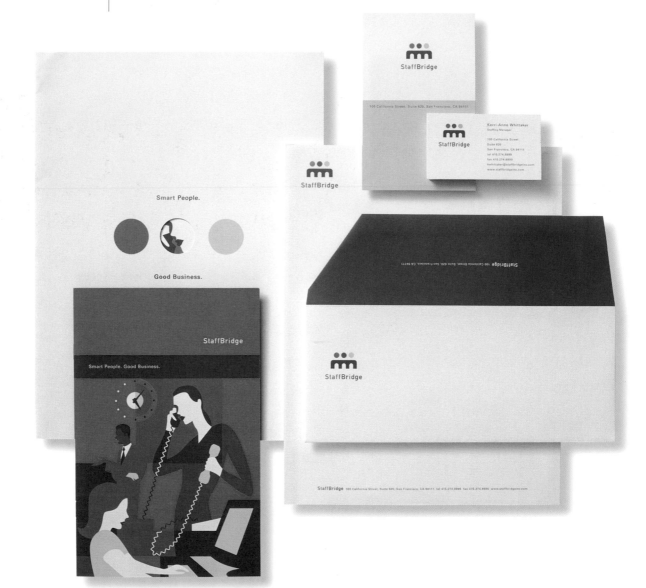

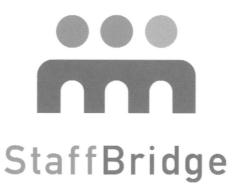

DESIGN FIRM	R2 Design/Ramalho & Rebelo, Lda.
ART DIRECTORS	Liza Ramalho, Artur Rebelo
DESIGNERS	Liza Ramalho, Artur Rebelo
CLIENT	West Coast
TOOL	Macromedia FreeHand

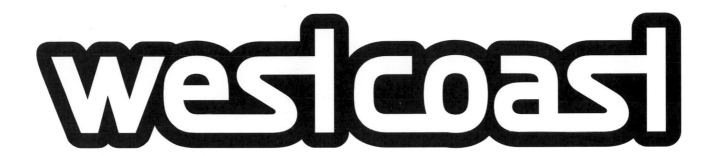

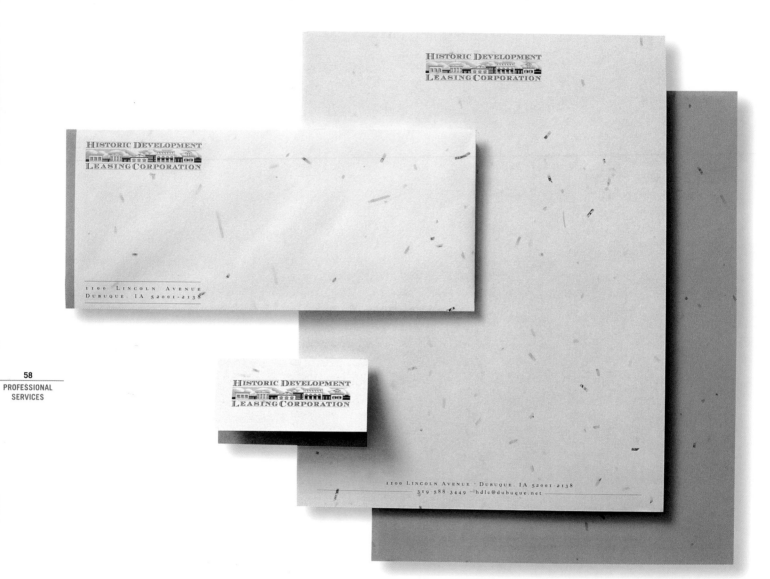

DESIGN FIRM	Refinery Design Company
ART DIRECTOR	Michael Schmalz
DESIGNER	Michael Schmalz
CLIENT	Historical Development Leasing Corporation
TOOLS	Macromedia FreeHand, Macintosh

i-connect

DESIGN FIRM	The Riordon Design Group
ART DIRECTORS	Ric Riordon, Dan Wheaton
DESIGNER	Alan Krpan
CLIENT	Ford Motor Company/Canada
TOOL	Adobe Illustrator

DESIGN FIRM	Sayles Graphic Design
ART DIRECTOR	John Sayles
DESIGNER	John Sayles
CLIENT	Car Hop
TOOLS	Adobe Illustrator, Macintosh

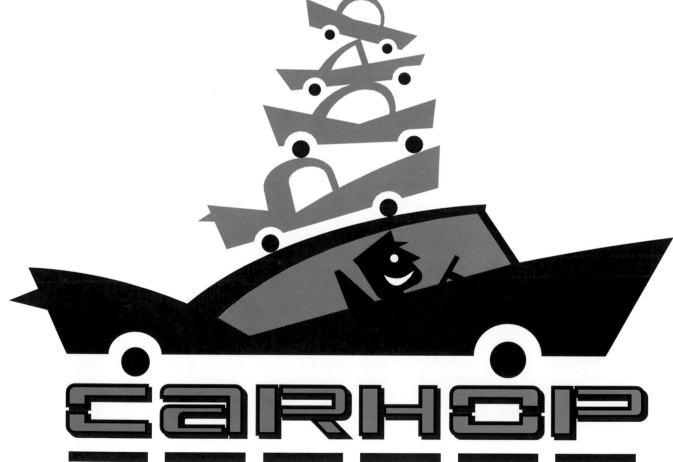

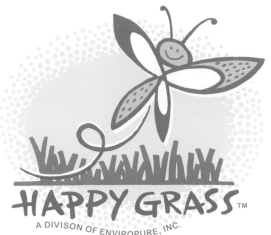

HAPPY GRASS™

A DIVISON OF ENVIROPURE, INC.

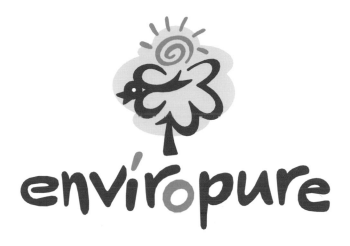

enviropure

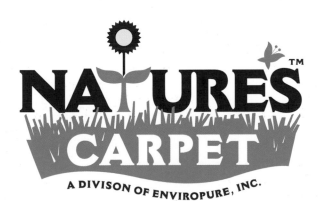

NATURE'S™

CARPET

A DIVISON OF ENVIROPURE, INC.

DESIGN FIRM	Sayles Graphic Design
ART DIRECTOR	John Sayles
DESIGNER	John Sayles
CLIENT	McArthur Company
TOOLS	Adobe Illustrator, Macintosh

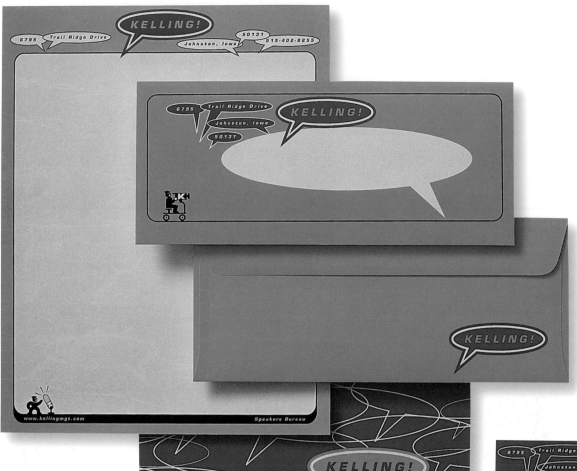

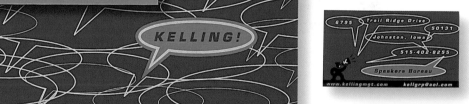

DESIGN FIRM	Sayles Graphic Design
ART DIRECTOR	John Sayles
DESIGNER	John Sayles
CLIENT	Kelling Management Group
TOOLS	Adobe Illustrator, Macintosh

DESIGN FIRM	WorldSTAR Design & Communications
ART DIRECTOR	Greg Guhl
DESIGNER	Greg Guhl
CLIENT	Acorn Landscaping Services
TOOLS	Adobe Illustrator, Macintosh

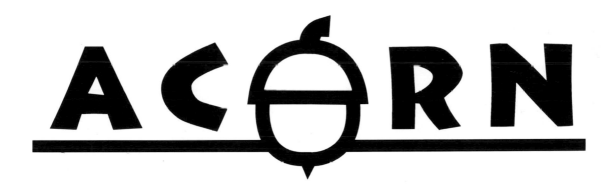

CREATIVE SERVICES

DESIGN FIRM | A1 Design
DESIGNER | Amy Gregg
CLIENT | A1 Design
TOOLS | Adobe Illustrator, Macintosh

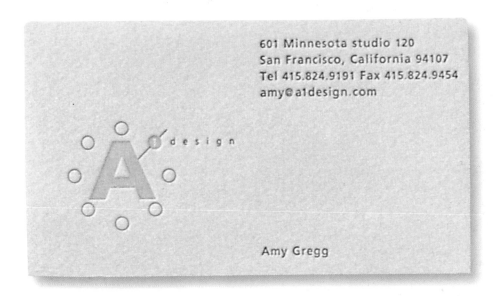

601 Minnesota studio 120
San Francisco, California 94107
Tel 415.824.9191 Fax 415.824.9454
amy@a1design.com

Amy Gregg

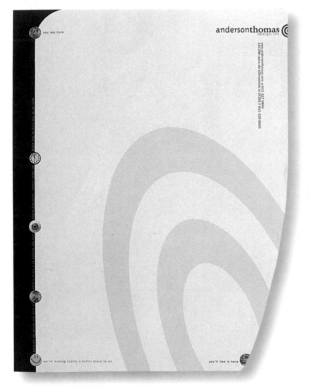

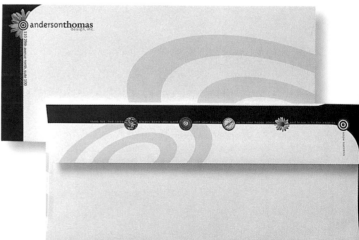

DESIGN FIRM	Anderson Thomas Design
ART DIRECTORS	Joel Anderson, Roy Roper
DESIGNER	Roy Roper
CLIENT	Anderson Thomas Design
TOOLS	Quark XPress, Adobe Illustrator, Adobe Photoshop

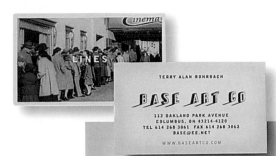

LINES

POINTS

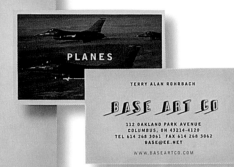

PLANES

TERRY ALAN ROHRBACH

BASE ART CO

112 OAKLAND PARK AVENUE
COLUMBUS, OH 43214-4120
TEL 614 268 3061 FAX 614 268 3062
BASE@EE.NET
WWW.BASEARTCO.COM

TERRY ALAN ROHRBACH

BASE ART CO

112 OAKLAND PARK AVENUE
COLUMBUS, OH 43214-4120
TEL 614 268 3061 FAX 614 268 3062
BASE@EE.NET
WWW.BASEARTCO.COM

TERRY ALAN ROHRBACH

BASE ART CO

112 OAKLAND PARK AVENUE
COLUMBUS, OH 43214-4120
TEL 614 268 3061 FAX 614 268 3062
BASE@EE.NET
WWW.BASEARTCO.COM

B
A
S
E

ART

BASE ART CO. 112 OAKLAND PARK AVENUE, COLUMBUS, OH 43214-4120 TEL 614 268 3061 FAX 614 268 3062 BASE@EE.NET

DESIGN FIRM	Base Art Co.
ART DIRECTOR	Terry Alan Rohrbach
DESIGNER	Terry Alan Rohrbach
CLIENT	Base Art Co.
TOOLS	Quark XPress, Macintosh

DESIGN FIRM	Buchanan Design
ART DIRECTOR	Bobby Buchanan
DESIGNERS	Armando Abundis, Bobby Buchanan
CLIENT	Buchanan Design
TOOLS	Adobe Illustrator, Macintosh

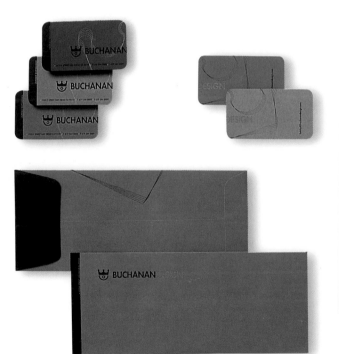

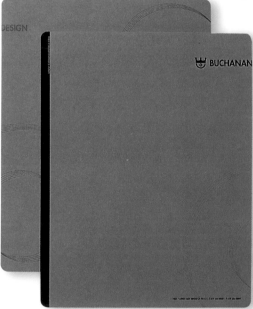

DESIGN FIRM	Bullet Communications, Inc.
ART DIRECTOR	Timothy Scott Kump
DESIGNER	Timothy Scott Kump
CLIENT	Bullet Communications, Inc.
TOOLS	Adobe Illustrator, Macintosh

BULLET COMMUNICATION
200 S. MIDLAND AVE JOLIET, ILLI

www.BulletCommunications.

TIMOTHY SCOTT KUMP
PRINCIPAL / CREATIVE DIRECTOR

ULLET COMMUNICATIONS, INC.®
S. MIDLAND AVE JOLIET, ILLINOIS 60436
EL: 815 741 2804 FAX: 815 741 2805
www.BulletCommunications.com
E-mail: 007@BulletCommunications.com

BULLET COMMUNICATIONS, INC.®
200 S. MIDLAND AVE JOLIET, ILLINOIS 60436 TEL: 815 741 2804 FAX: 815 741 2805
www.BulletCommunications.com E-mail: 007@BulletCommunications.com

Bullet Communications, Inc., and its logo are registered service marks of Bullet Communications, Inc.

DESIGN FIRM | Becker Design
DESIGNER | Neil Becker
CLIENT | Charlton Photos, Inc.
TOOLS | Adobe Illustrator, Macintosh

Stock Photography
Assignment Photography
Stock Video
Video Production

Stock Photography
Assignment Photography
Stock Video
Video Production

Jim Charlton II

11518 North Port Washington Road
Mequon, Wisconsin 53092
Ph: 414 241-8634 Fx: 414 241-46
email: charlton@execpc.com
www.charltonphotos.com

Charlton Photos Inc

Charlton Photos Inc 11518 North Port Wash

11518 North Port Washington Road Mequon, Wisconsin 53092

11518 North Port Washington Road Mequon, Wisconsin 53092 Ph: 414 241-8634 Fx: 414 241-4612
email: charlton@execpc.com www.charltonphotos.com

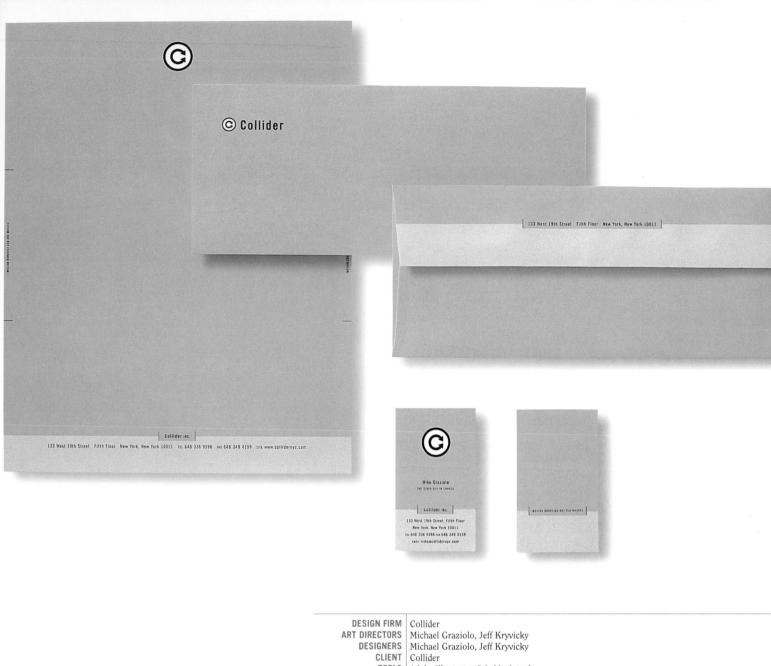

DESIGN FIRM	Collider
ART DIRECTORS	Michael Graziolo, Jeff Kryvicky
DESIGNERS	Michael Graziolo, Jeff Kryvicky
CLIENT	Collider
TOOLS	Adobe Illustrator 8.0, Macintosh

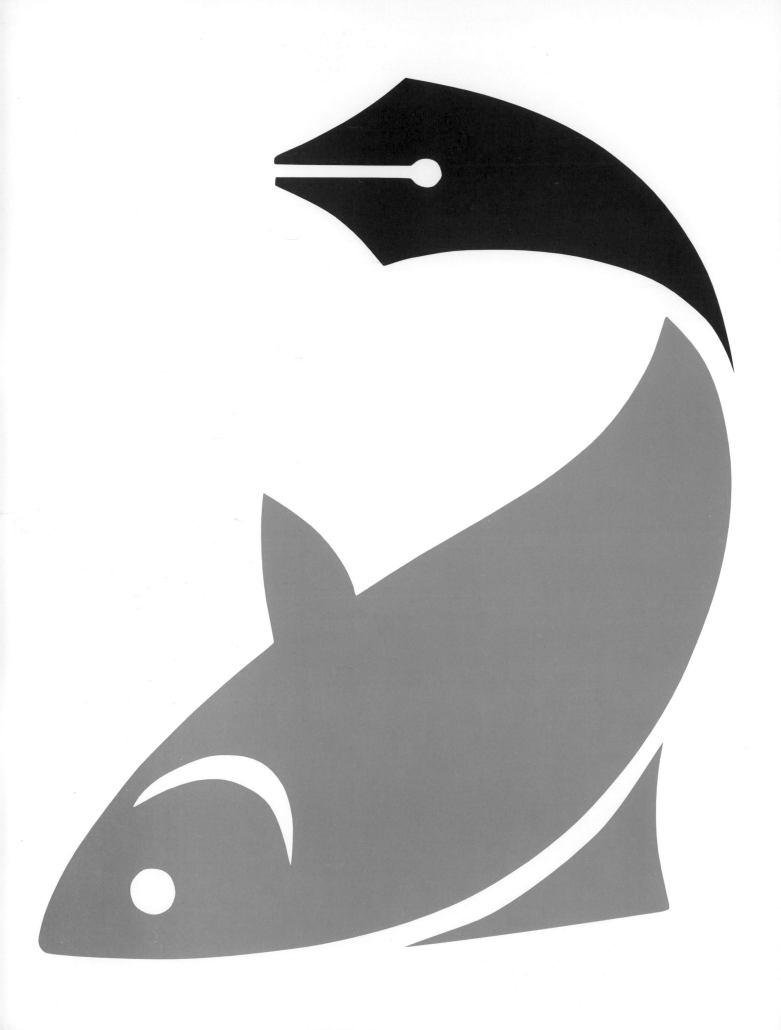

DESIGN FIRM	DGWB
DESIGN DIRECTOR	Jonathan Brown
DESIGNER	Conan Wang
CLIENT	DGWB
TOOL	Adobe Illustrator 8.0.1

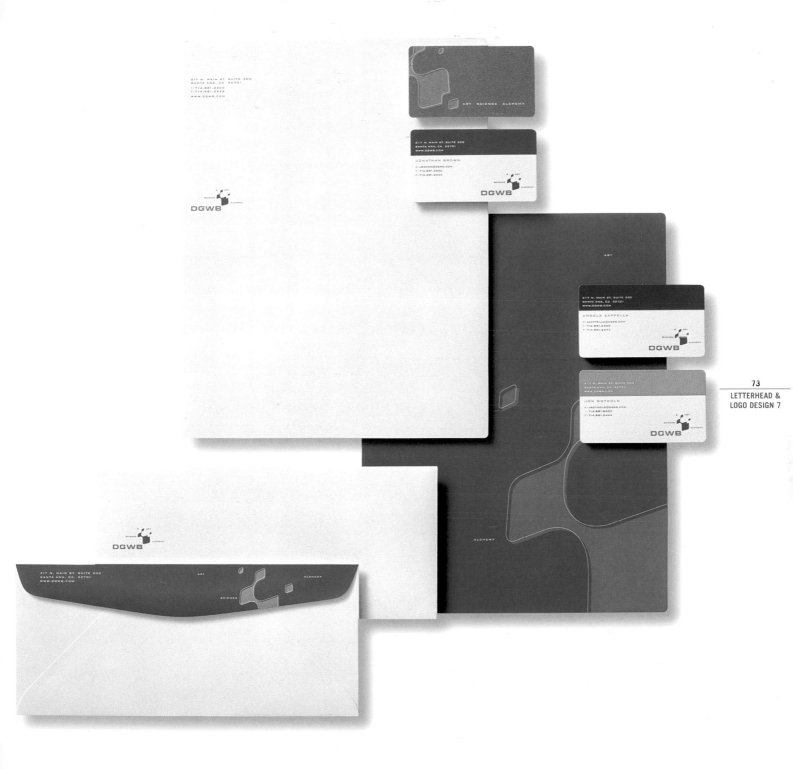

DESIGN FIRM	DogStar
DESIGNER	Rodney Davidson
CLIENT	Cathy Fishel, Copywriter
TOOL	Macromedia FreeHand 7

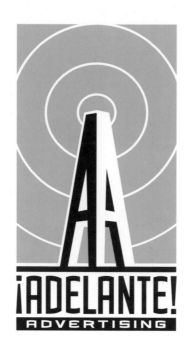

DESIGN FIRM	DGWB
DESIGN DIRECTOR	Jonathan Brown
DESIGNER	Conan Wang
CLIENT	Adelante
TOOL	Adobe Illustrator 8.0.1

DESIGN FIRM	Dynamo Design
DESIGNER	Alan Bennis
CLIENT	Design Partners
TOOLS	Adobe Illustrator, Adobe Photoshop, Quark XPress

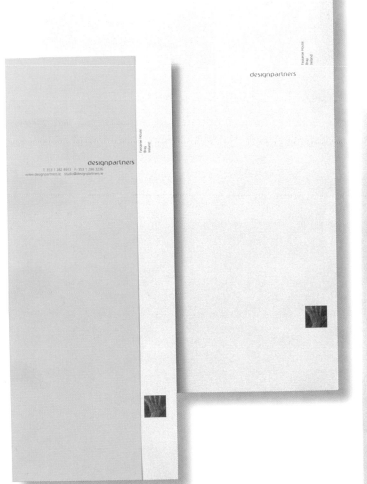

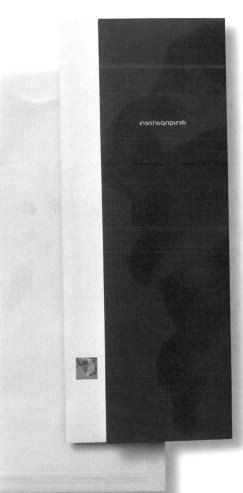

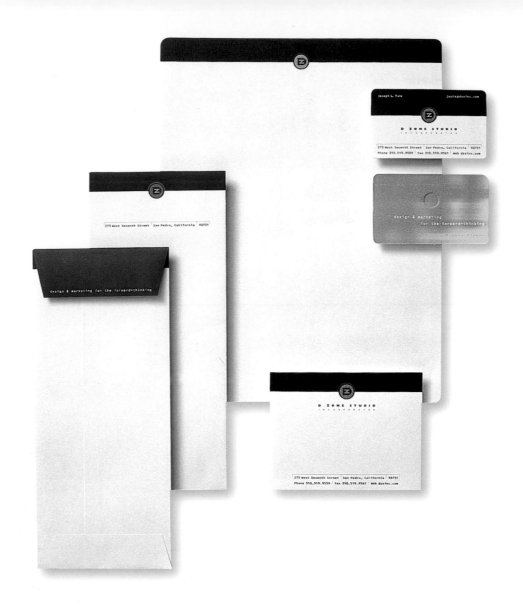

DESIGN FIRM	D Zone Studio
ART DIRECTOR	Joe Yule
DESIGNER	Joe Yule
CLIENT	D Zone Studio
TOOLS	Adobe Illustrator, Macintosh

DESIGN FIRM	Graphiculture
ART DIRECTOR	Cheryl Watson
DESIGNERS	Lindsay Little, Beth Mueller
CLIENT	Graphiculture
TOOLS	Quark XPress, Macromedia FreeHand

GRAPHICULTURE

TELEPHONE 612.339.8271 · FACSIMILE 612.339.1436 · WORLD WIDE WEB graphiculture.com · E-MAIL design@graphiculture.com

GRAPHICULTURE
322 first avenue north suite 304
minneapolis, mn 55401

GRAPHICULTURE
322 first avenue north suite 304
minneapolis, mn 55401

GRAPHICULTURE
322 first avenue north suite 304
minneapolis, mn 55401

LIENT:

OB DESCRIPTION:

UBJECT:

ATE:

GRAPHICULTURE
322 first avenue north suite 304
minneapolis, mn 55401

GRAPHICULTURE
322 first avenue north suite 304
minneapolis, mn 55401

GRAPHICUL
322 firs
CHERYL WATSON
cheryl@graphicult

WWW.GRAPHICULTURE.COM

DESIGN FIRM	Gardner Design
ART DIRECTOR	Brian Miller
DESIGNER	Brian Miller
CLIENT	John Crowe Photography
TOOL	Macromedia FreeHand

JOHN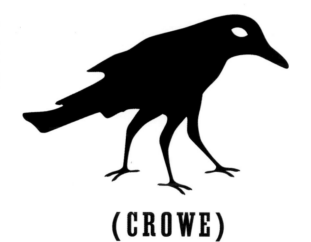

(CROWE)

DESIGN FIRM	Gardner Design
ART DIRECTORS	Bill Gardner, Brian Miller
DESIGNER	Brian Miller
CLIENT	Paul Chauncey Photography
TOOL	Macromedia FreeHand

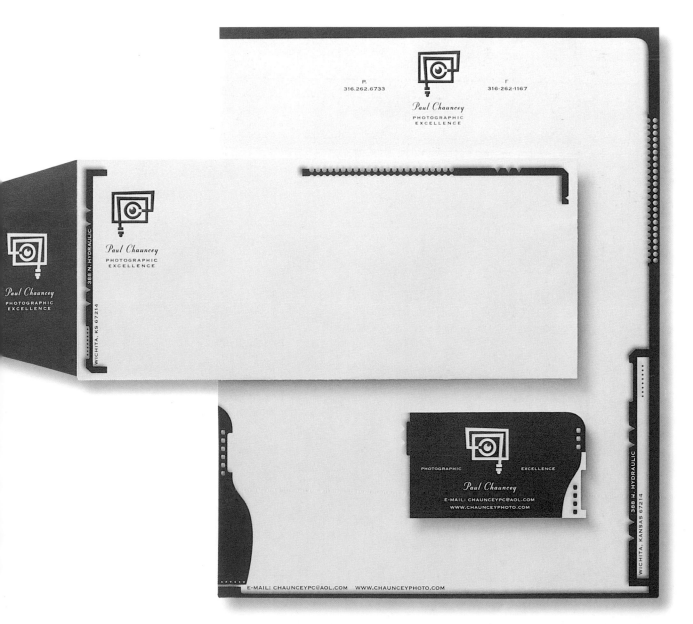

Turtle Airways LTD

Private Mail Bag
NAP 0355
Nadi International
Airport, Fiji

Turtle Airways LTD

Private Mail Bag
NAP 0355
Nadi International
Airport, Fiji

Turtle Airways LTD

Private Mail Bag Tel: (679) 721 888
NAP 0355 Fax: (679) 720 095
Nadi International e-mail: southseaturtle@is.com.fj
Airport, Fiji

Tel: (679) 721 888
Fax: (679) 720 095
e-mail: southseaturtle@is.com.fj

DESIGN FIRM	KAISERDICKEN
ART DIRECTOR	Craig Dicken
DESIGNERS	Craig Dicken, Debra Kaiser, Anthony Sini
CLIENT	Turtle Airways
TOOLS	Quark XPress, Adobe Illustrator, Adobe Photoshop, Macintosh

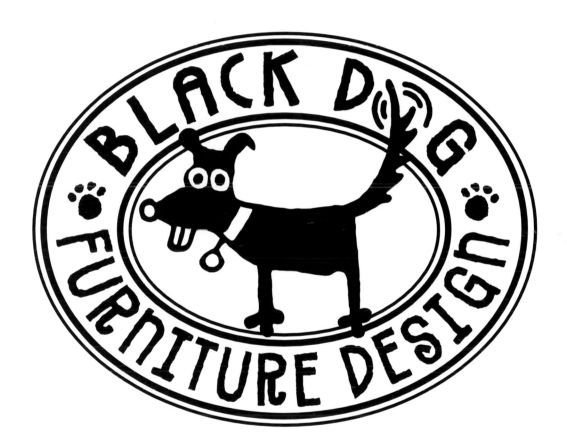

DESIGN FIRM	Jeff Fisher LogoMotives
ART DIRECTOR	Jeff Fisher
DESIGNERS	Jeff Fisher, Brett Bigham
CLIENT	Black Dog Furniture Design
TOOLS	Macromedia FreeHand, Macintosh

KIMBERLY WATERS

DESIGN FIRM	Jeff Fisher LogoMotives
ART DIRECTOR	Jeff Fisher
DESIGNER	Jeff Fisher
CLIENT	Kimberly Waters
TOOLSO	Macromedia FreeHand, Macintosh

DESIGN FIRM	Nassar Design
ART DIRECTOR	Nelida Nassar
DESIGNER	Margarita Encorienda
CLIENT	Nassar Design
TOOLS	Adobe Illustrator, Quark XPress, Adobe Photoshop

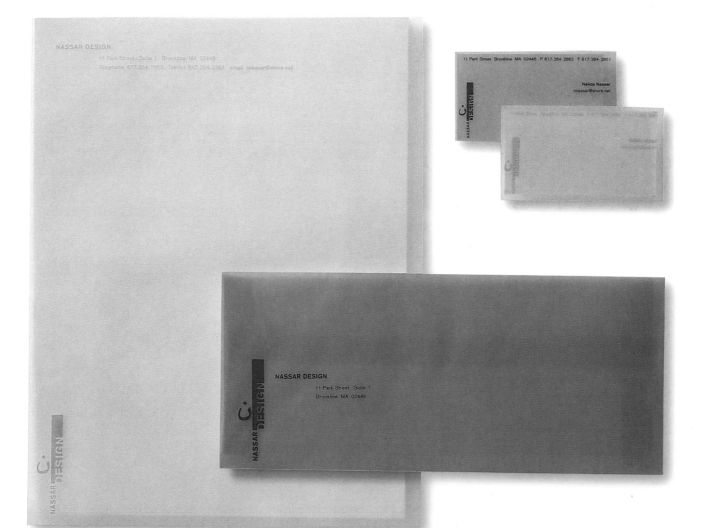

The stationery design reads:

doug baldwin · writing services

I do everything write.

scripts
multimedia
brochures
advertising

503·452·9411

2002 sw dolph court
portland, oregon 97219
fax me
503·244·3756
e-mail
dbaldwin@teleport.com

DESIGN FIRM	Oakley Design Studios
ART DIRECTOR	Tim Oakley
DESIGNER	Tim Oakley
CLIENT	Doug Baldwin, Copywriter
TOOL	Adobe Illustrator 7.0

DESIGN FIRM	Punkt
ART DIRECTOR	Giles Dunn
DESIGNER	Giles Dunn
CLIENT	Big Fish Design Consultants
TOOL	Macromedia FreeHand

Design Consultants
10 Chelsea Wharf 15 Lots Roa

Design Consultants
10 Chelsea Wharf 15 Lots Road London SW10 0QJ T 020 7795 0075 studio@bigfish.co.uk www.bigfish.co.uk

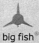

Perry Haydn Taylor
10 Chelsea Wharf 15 Lots Road London SW10 0QJ
T 020 7795 0075 F 020 7349 0539
perry@bigfish.co.uk www.bigfish.co.uk

Design Consultants
10 Chelsea Wharf 15 Lots Road London SW10 0QJ T 020 7795 0075 F 020 7349 0539 studio@bigfish.co.uk www.bigfish.co.uk
Big Fish Design Limited Registered no. 2972579 Registered office as above

DESIGN FIRM	PXL8R Visual Communications
PHOTOGRAPHER	Craig Molenhouse
DESIGNER	Craig Molenhouse
CLIENT	PXL8R Visual Communications
TOOLS	Adobe Photoshop, Adobe Illustrator, Quark XPress, Macintosh

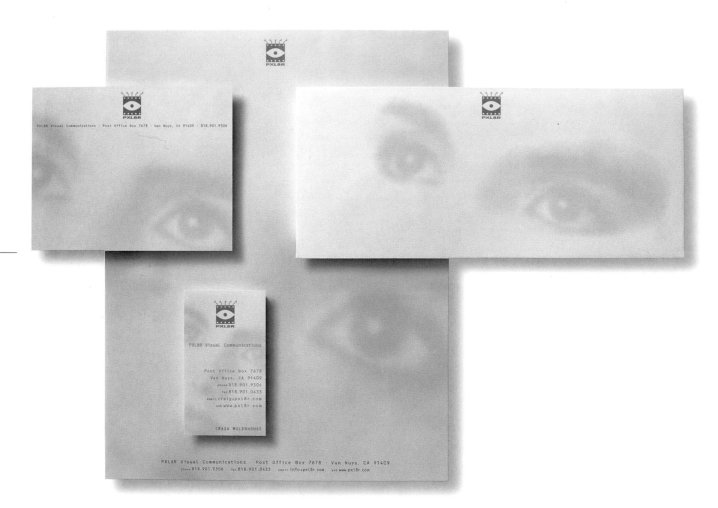

DESIGN FIRM	Refinery Design Company
ART DIRECTOR	Michael Schmalz
DESIGNERS	Daniel Schmalz, Julie Schmalz
CLIENT	Refinery Design Company
TOOLS	Macromedia FreeHand, Macintosh

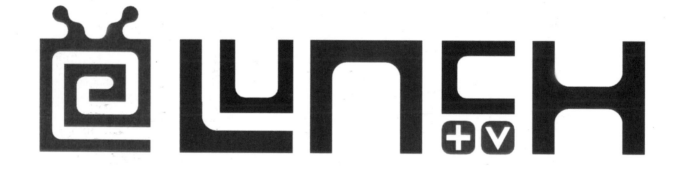

DESIGN FIRM	Stoltze Design
ART DIRECTOR	Clifford Stoltze
DESIGNERS	Tammy Dotson, Clifford Stoltze
CLIENT	Lunch TV
TOOLS	Adobe Illustrator, Macintosh

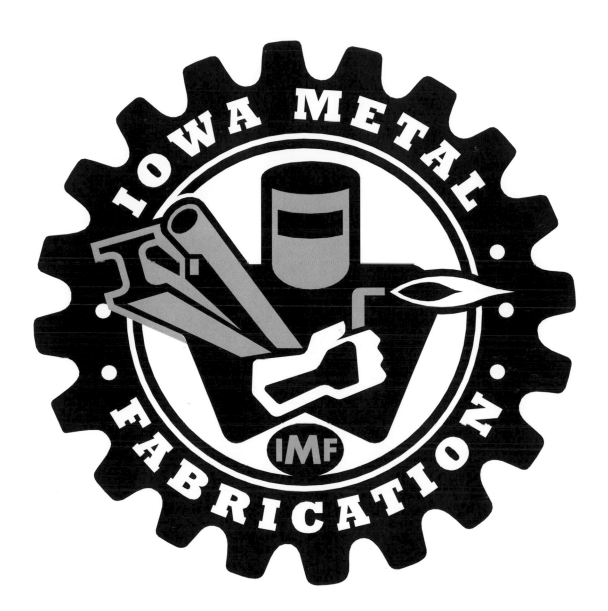

DESIGN FIRM	Sayles Graphic Design
ART DIRECTOR	John Sayles
DESIGNER	John Sayles
CLIENT	Iowa Metal Fabrication
TOOLS	Adobe Illustrator, Macintosh

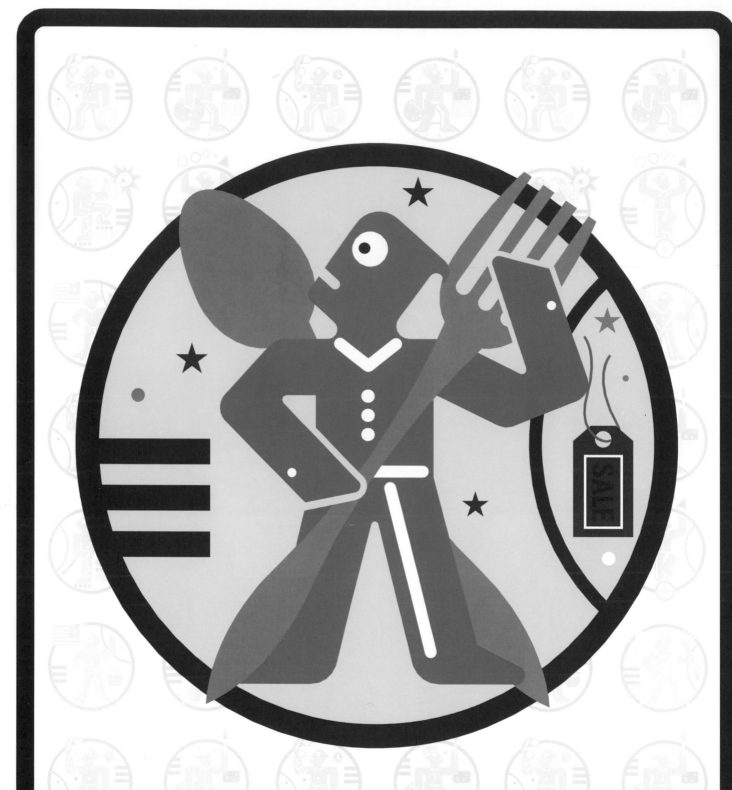

RETAIL, RESTAURANT, AND HOSPITALITY

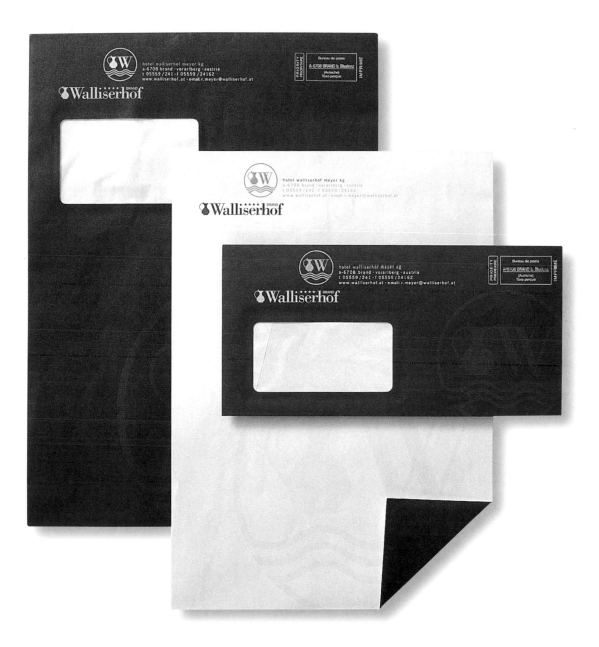

DESIGN FIRM	art+corporate culture
DESIGNER	Mag. Lothar Amilian Heinzle
CLIENT	Markus Maier
TOOLS	Macromedia FreeHand, Quark XPress

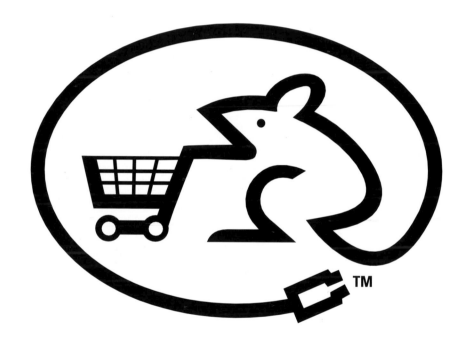

™

DESIGN FIRM	ARTiculation Group & Benchmark Porter Novelli
ART DIRECTOR	Joseph Chan
DESIGNER	Joseph Chan
CLIENT	The Shopping Channel
TOOL	Adobe Illustrator

DESIGN FIRM	Becker Design
DESIGNER	Neil Becker
CLIENT	A Food Affair
TOOLS	Adobe Illustrator, Macintosh

A FOOD AFFAIR
CATERING
VAIL, CO

PERSONALIZED
CATERING
for
EVERY AFFAIR

P.O. BOX 3844
VAIL, COLORADO 81658
PHONE 970 477-1073

WECATER@MOUNTAINMAX.NET

A FOOD AFFAIR
CATERING
VAIL, CO

BRENTS W. OLMSTED
FOOD OPERATION / CHEF

P.O. BOX 3844
VAIL, COLORADO 81658
PHONE 970 477-1073

WECATER@MOUNTAINMAX.NET

PERSONALIZED
CATERING
— *for* —
EVERY AFFAIR

PRIVATE PARTIES • BUFFETS • LUNCHEONS

COCKTAIL PARTIES • BOXED LUNCHES

SPECIAL EVENTS AND MORE

A FOOD AFFAIR
CATERING

P.O. BOX 3844
VAIL, COLORADO 81658

DESIGN FIRM	Bailey/Franklin
ART DIRECTOR	Dan Franklin
DESIGNER	Alex Epp
CLIENT	Boyd Coffee Company
TOOL	Macromedia FreeHand

DESIGN FIRM	Bruce Yelaska Design
ART DIRECTOR	Bruce Yelaska
DESIGNER	Bruce Yelaska
CLIENT	Hunan Garden
TOOLS	Adobe Illustrator, Macintosh

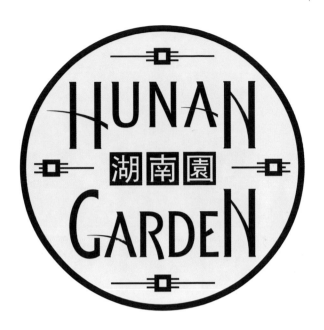

3345 El Camino Real | Palo Alto, CA 94306 | Tel: 650.565.8868 | Fax: 650.565.8818

3345 El Camino Real | Palo Alto, CA 94306

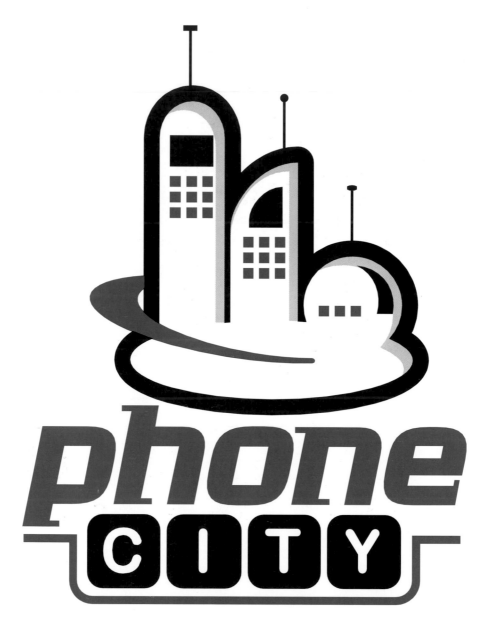

DESIGN FIRM | cincodemayo
ART DIRECTOR | Mauricìo Alanis
DESIGNER | Mauricìo Alanis
CLIENT | Phone City
TOOLS | Macromedia FreeHand, Macintosh

DESIGN FIRM	cincodemayo
ART DIRECTOR	Mauricìo Alanis
DESIGNER	Mauricìo Alanis
CLIENT	2fiesta.com
TOOLS	Macromedia FreeHand, Macintosh

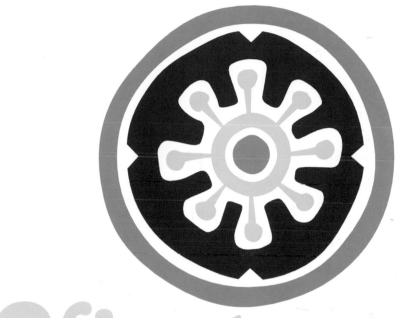

2fiesta.com

LATIN AMERICAN PASSION

DESIGN FIRM	cincodemayo
ART DIRECTOR	Mauricìo Alanis
DESIGNER	Mauricìo Alanis
CLIENT	Kamikaze
TOOLS	Macromedia FreeHand, Macintosh

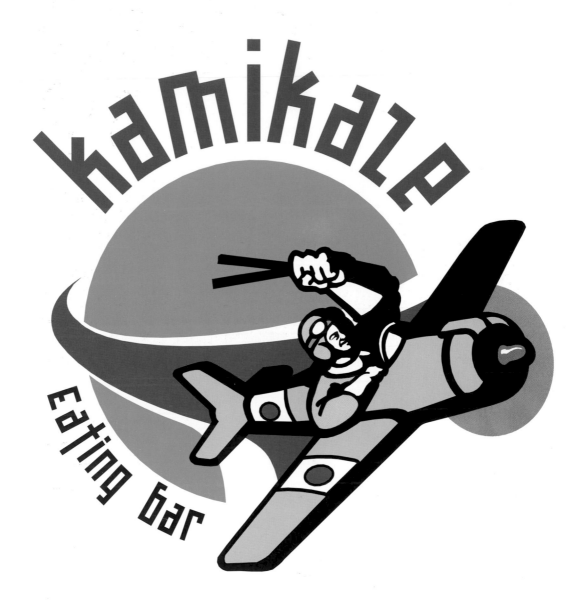

DESIGN FIRM	Cato Partners
DESIGNER	Cato Partners
CLIENT	Poppy Industries Pty. Ltd.
TOOLS	Adobe Illustrator 6, Macintosh

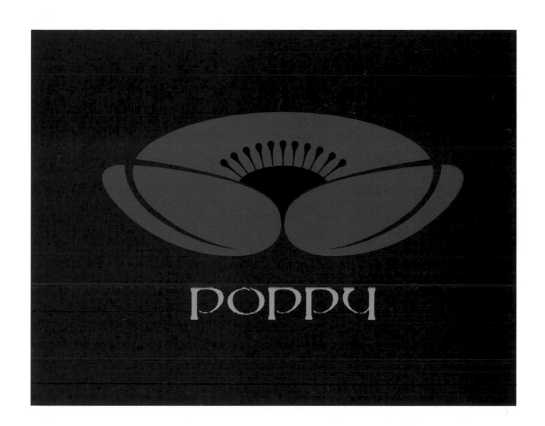

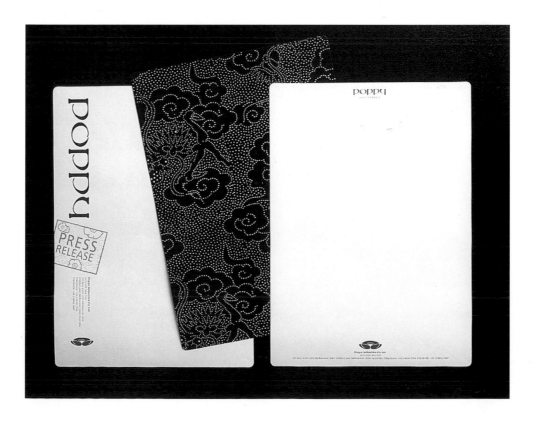

SIMPLE to GRAND

DESIGN FIRM | Design Center
ART DIRECTOR | John Reger
DESIGNER | Sherwin Schwartzrock
CLIENT | Simple to Grand
TOOLS | Macromedia FreeHand, Macintosh

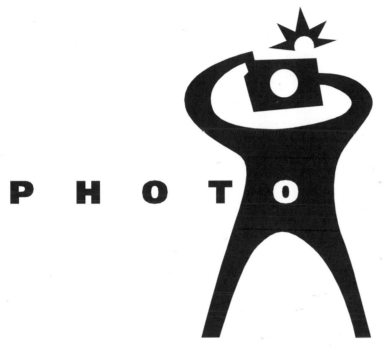

PHOTO MAN

DESIGN FIRM | Design Center
ART DIRECTOR | John Reger
DESIGNER | Cory Docken
CLIENT | Photoman
TOOLS | Macromedia FreeHand, Macintosh

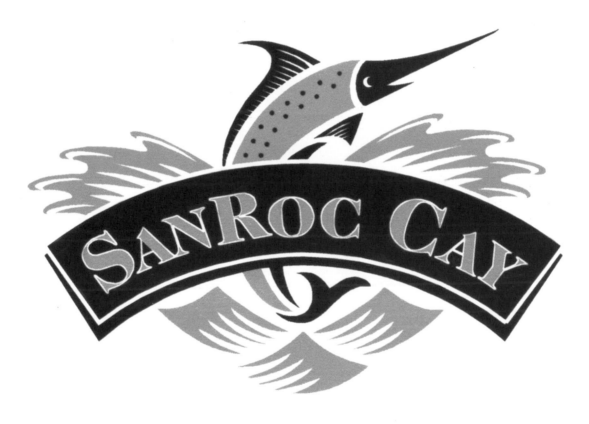

DESIGN FIRM	DogStar
ART DIRECTOR	Lynn Smith/Perry, Harper & Perry Advertising
DESIGNER	Rodney Davidson
CLIENT	San Roc Cay Resort
TOOL	Macromedia FreeHand 7

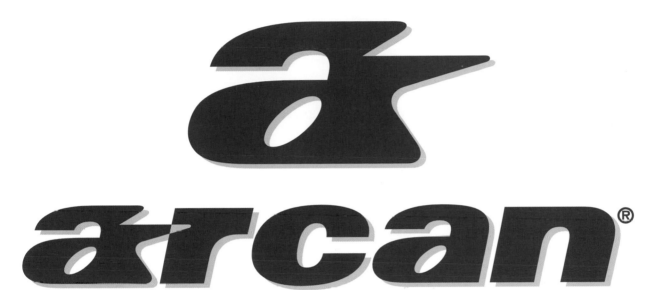

DESIGN FIRM	Di Luzio D.G. & Comunicación
DESIGNER	Hector Di Luzio
CLIENT	Acron S.A.
TOOLS	Adobe Illustrator, Macintosh

Grand Boulevard Hotel

BUENOS AIRES

DESIGN FIRM	Di Luzio D.G. & Comunicación
DESIGNER	Hector Di Luzio
CLIENT	Transcontinental Hotel S.A.
TOOLS	Adobe Illustrator, Macintosh

DESIGN FIRM	Gardner Design
ART DIRECTOR	Bill Gardner
DESIGNER	Bill Gardner
CLIENT	Plazago
TOOL	Macromedia FreeHand

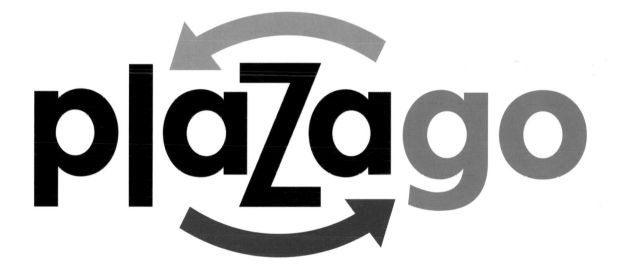

DESIGN FIRM	Gardner Design
ART DIRECTOR	Chris Parks
DESIGNER	Chris Parks
CLIENT	Big Fish
TOOL	Macromedia FreeHand

DESIGN FIRM | Gardner Design
ART DIRECTORS | Travis Brown, Bill Gardner
DESIGNER | Travis Brown
CLIENT | Iron Easel
TOOL | Macromedia FreeHand

Slow Cooked • Easy to Prepare **BUTCHER & COOK'S** *Marinated • Great Tasting*

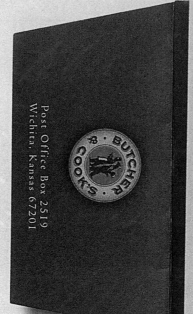

Post Office Box 2519
Wichita, Kansas 67201

PO Box 2519 Wichita, KS 67201 • e-mail: butchercooks@

DESIGN FIRM | Hornall Anderson Design Works, Inc.
ART DIRECTORS | Larry Anderson, Jack Anderson
DESIGNERS | Jack Anderson, Larry Anderson, Bruce Stigler,
Bruce Branson-Meyer, Mary Chin Hutchison,
Michael Brugman, Ed Lee, Kaye Farmer
CLIENT | Widmer Brothers
TOOL | Macromedia FreeHand

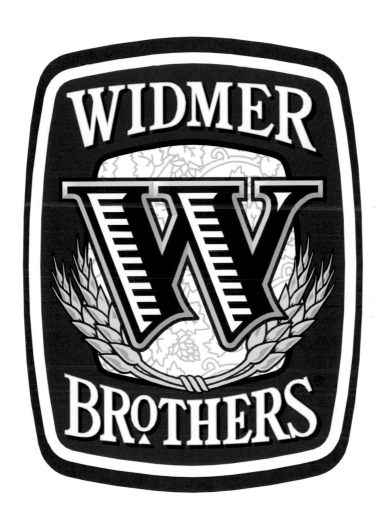

DESIGN FIRM | Gardner Design
ART DIRECTORS | Brian Miller, Bill Gardner
DESIGNER | Brian Miller
CLIENT | Butcher & Cooks
TOOLS | Macromedia FreeHand, Adobe Photoshop

COUGAR MOUNTAIN GOURMET COOKIES

DESIGN FIRM	Hornall Anderson Design Works, Inc.
ART DIRECTORS	Jack Anderson, Debra McCloskey
DESIGNERS	Jack Anderson, Debra McCloskey, Lisa Cerveny, Mary Chin Hutchison, Gretchen Cook, Holly Craven, Dorothee Soechting
CLIENT	Cougar Mountain Cookies
TOOL	Macromedia FreeHand

DESIGN FIRM	Hornall Anderson Design Works, Inc.
ART DIRECTOR	Jack Anderson
DESIGNERS	Jack Anderson, Kathy Saito,
	Mary Chin Hutchison, Alan Copeland
CLIENT	Big Island Candies
TOOL	Macromedia FreeHand

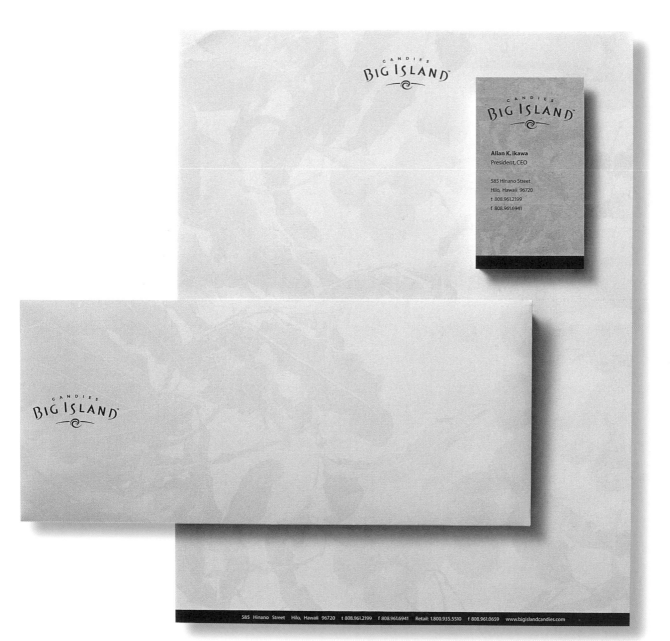

DESIGN FIRM	Hornall Anderson Design Works, Inc.
ART DIRECTOR	Lisa Cerveny
DESIGNERS	Lisa Cerveny, Michael Brugman, Rick Miller,
	Belinda Bowling, Mary Hermes
CLIENT	Hardware.com
TOOL	Adobe Illustrator

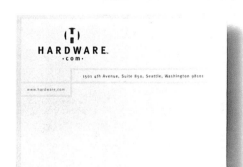

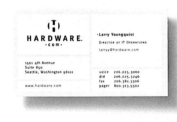

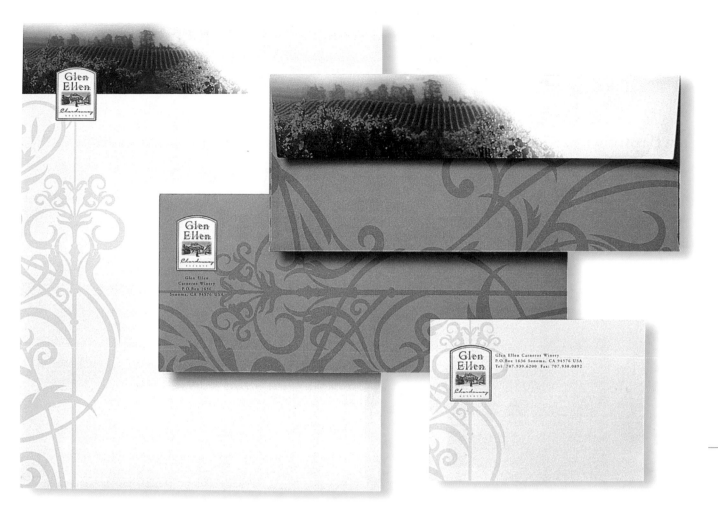

DESIGN FIRM	Halleck
ART DIRECTORS	Daniel Tang, Wayne Wright
DESIGNERS	Daniel Tang, Wayne Wright
CLIENT	Glen Ellen Carneros Winery
TOOLS	Adobe Photoshop, Macintosh

DESIGN FIRM	Insight Design Communications
ART DIRECTORS	Sherrie & Tracy Holdeman
DESIGNERS	Sherrie & Tracy Holdeman
CLIENT	Richard Lynn's Shoe Market
TOOL	Macromedia FreeHand 9.0.1

DESIGN FIRM	Insight Design Communications
ART DIRECTORS	Sherrie & Tracy Holdeman
DESIGNERS	Sherrie & Tracy Holdeman
CLIENT	Dino's Italian Grille
TOOLS	Hand Drawn, Macromedia FreeHand 9.0.1

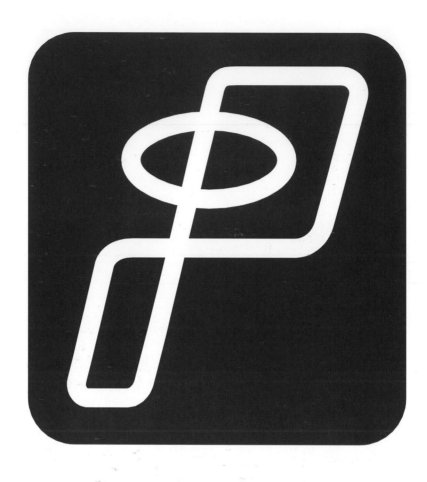

DESIGN FIRM	Insight Design Communications
ART DIRECTORS	Sherrie & Tracy Holdeman
DESIGNERS	Sherrie & Tracy Holdeman
CLIENT	Perfect Pitch Sound Systems
TOOLS	Hand Drawn, Macromedia FreeHand 9.0.1

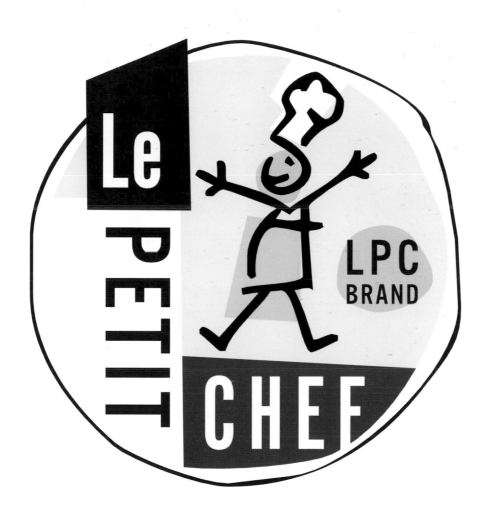

DESIGN FIRM	Insight Design Communications
ART DIRECTORS	Sherrie & Tracy Holdeman
DESIGNERS	Sherrie & Tracy Holdeman
CLIENT	Le Petit Chef
TOOLS	Hand Drawn, Macromedia FreeHand 9.0.1

DESIGN FIRM	Karacters Design Group
ART DIRECTORS	Maria Kennedy, Roy White
DESIGNER	Matthew Clark
CLIENT	Overwaitea Food Group Urban Fare
TOOL	Adobe Illustrator

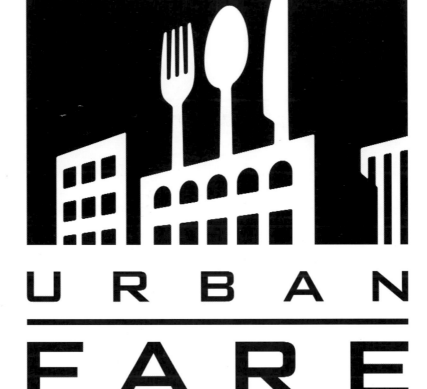

URBAN
FARE

DESIGN FIRM | Lebowitz/Gould/Design, Inc.
ART DIRECTORS | Sue Gould, Trisia Tomanelli
DESIGNER | Trisia Tomanelli
CLIENT | An American Restaurant Group
TOOLS | Adobe Illustrator, Macintosh

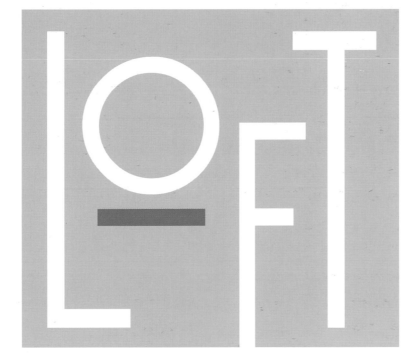

VELVET

BAR

DESIGN FIRM	Lebowitz/Gould/Design, Inc.
ART DIRECTORS	Sue Gould, Susan Chait, Maura Callahan
DESIGNER	Maura Callahan
CLIENT	Velvet Bar at the Hard Rock Hotel, Orlando, Florida
TOOLS	Adobe Illustrator, Macintosh

DESIGN FIRM	Jeff Fisher LogoMotives
ART DIRECTOR	Jeff Fisher
DESIGNER	Jeff Fisher
CLIENT	W.C. Winks Hardware
TOOLS	Macromedia FreeHand, Macintosh

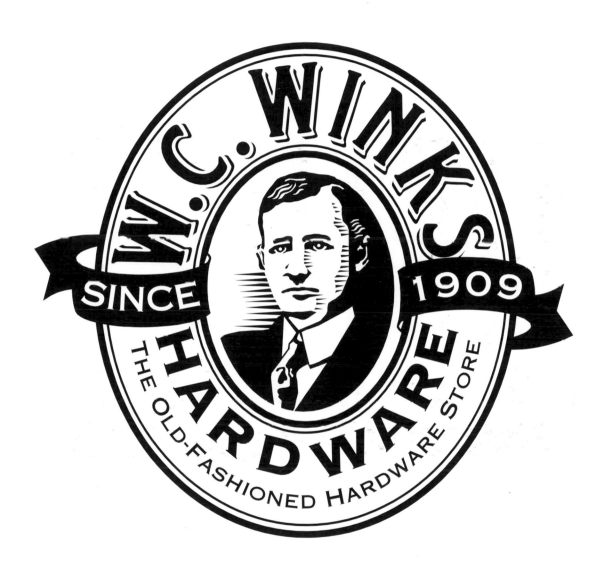

DESIGN FIRM	Jeff Fisher LogoMotives
ART DIRECTOR	Jeff Fisher
DESIGNER	Jeff Fisher
CLIENT	Peggy Sundays
TOOLS	Macromedia FreeHand, Macintosh

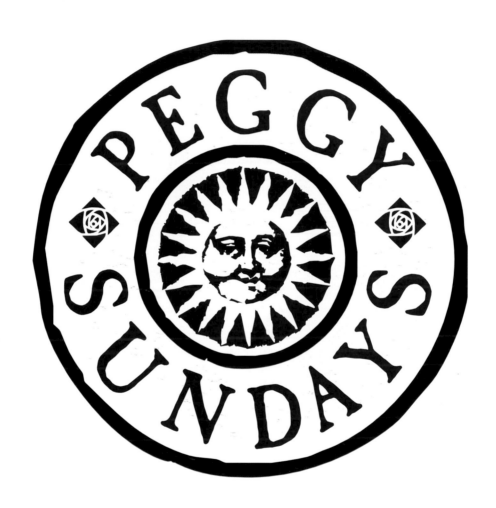

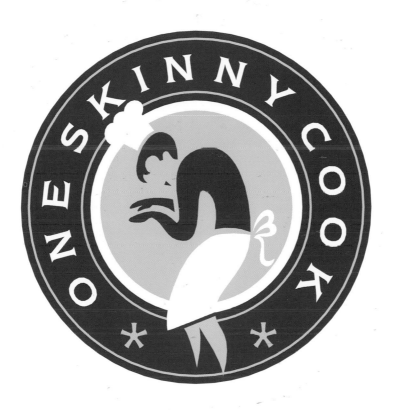

DESIGN FIRM | Lloyds Graphic Design & Communication
ART DIRECTOR | Alexander Lloyd
DESIGNER | Alexander Lloyd
CLIENT | One Skinny Cook
TOOLS | Macromedia FreeHand, Macintosh

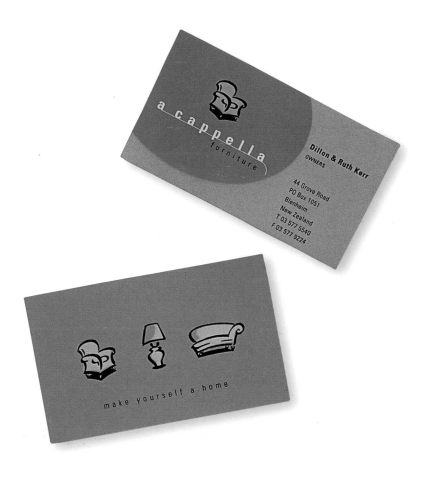

DESIGN FIRM	Lloyds Graphic Design & Communication
ART DIRECTOR	Alexander Lloyd
DESIGNER	Alexander Lloyd
CLIENT	A Cappella Furniture
TOOLS	Macromedia FreeHand, Macintosh

DESIGN FIRM	Louey/Rubino Design Group
ART DIRECTOR	Robert Louey
CREATIVE DIRECTOR	Tony Chi & Associates
DESIGNER	Alex Chao
CLIENT	NoMi
TOOLS	Quark XPress, Adobe Illustrator, Macintosh

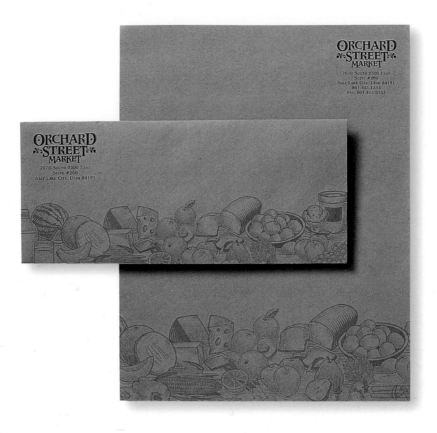

·ORCHARD· ❖STREET❖ MARKET

DESIGN FIRM	Love Communications
ART DIRECTOR	Preston Wood
CLIENT	Orchard Street Market
TOOLS	Adobe Illustrator, Quark XPress

DESIGN FIRM | Total Creative
ART DIRECTOR | Rod Dyer
DESIGNER | Michael Doret
CLIENT | Hollywood & Vine Diner
TOOL | Adobe Illustrator 8.01

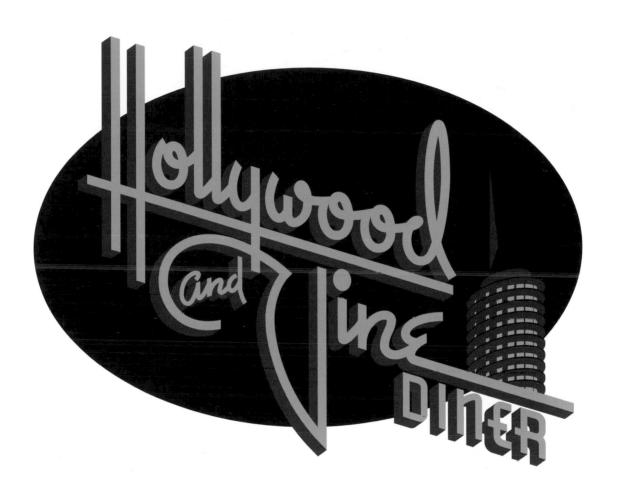

ENGFER PIZZA WORKS

WOOD-FIRED

DESIGN FIRM	Energy Energy Design
ART DIRECTOR	Leslie Guidice
SENIOR DESIGNER	Stacy Guidice
ILLUSTRATOR	Tim Harris
CLIENT	Engfer Pizza Works
TOOLS	Adobe Illustrator, Macintosh

urban feast

DESIGN FIRM	Nesnadny + Schwartz
ART DIRECTOR	Joyce Nesnadny
DESIGNERS	Joyce Nesnadny, Cindy Lowrey
CLIENT	Urban Feast
TOOLS	Macromedia FreeHand 8.0, Macintosh

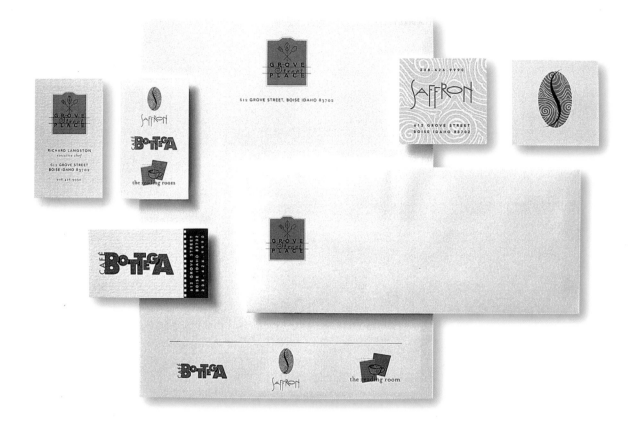

RETAIL,
RESTAURANT,
AND HOSPITALITY

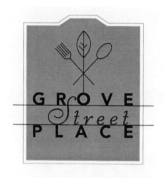

DESIGN FIRM | Oliver Russell & Associates
ART DIRECTOR | Kristy Weyhrich
DESIGNER | Kristy Weyhrich
CLIENT | Alan Head, Grove Street Place
TOOLS | Adobe Illustrator 8.0, Macintosh G4

DESIGN FIRM	PM Design
ART DIRECTOR	Philip Marzo
DESIGNER	Philip Marzo
CLIENT	B. Heaven.
TOOL	Adobe Illustrator 8.0

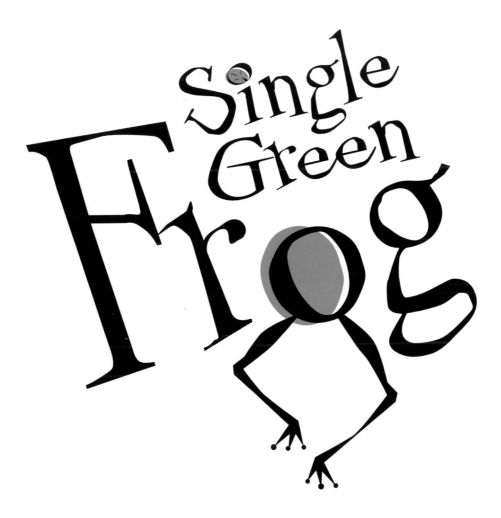

DESIGN FIRM	Palmquist Creative
ART DIRECTOR	Andrea Stevenson
DESIGNER	Kelly Bellcour
CLIENT	Big Sky Carvers–Single Green Frog
TOOLS	Adobe Illustrator, Macintosh

DESIGN FIRM	Shamlian Advertising
ART DIRECTOR	Fred Shamlian
DESIGNERS	Darren Taylor, Edgar Uy
CLIENT	Du Jour Catering
TOOLS	Macintosh, Adobe Illustrator 8.0, Quark XPress 4.1

du jour
market / catering / patisserie

du jour
market / catering / patisserie

sally walsh proprietor
haverford square 379 lancaster ave. haverford, PA 19041
tel. 610.896.4556 **fax** 610.896.5944

du jour
market / catering / patisserie

haverford square
379 lancaster ave.
haverford, PA 19041

du jour market/catering/patisserie haverford square 379 lancaster ave. haverford, PA 19041 **tel.** 610.896.4556 **fax** 610.896.5944

DESIGN FIRM	Second Floor
ART DIRECTOR	Warren Welter
DESIGNER	Chris Twilling
CLIENT	Personality Hotels
TOOLS	Adobe Illustrator, Quark XPress, Macintosh

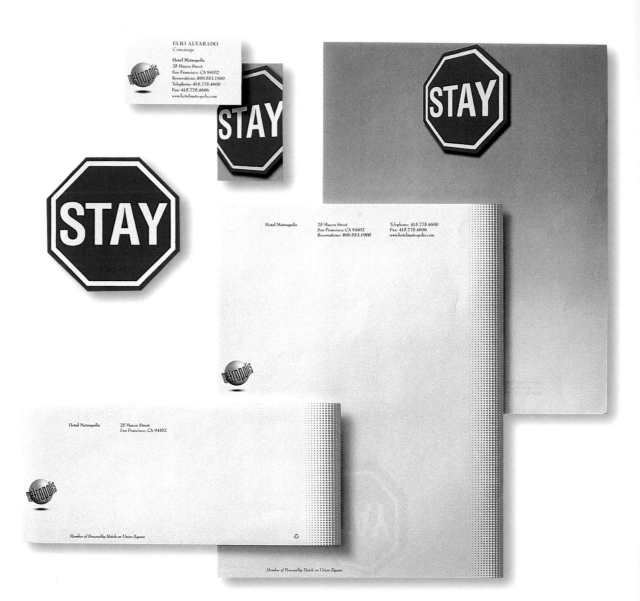

DESIGN FIRM | Second Floor
ART DIRECTOR | Warren Welter
DESIGNER | Andrea Griffin
CLIENT | Vine Solutions/Glow
TOOLS | Adobe Photoshop, Adobe Illustrator,
Quark XPress, Macintosh

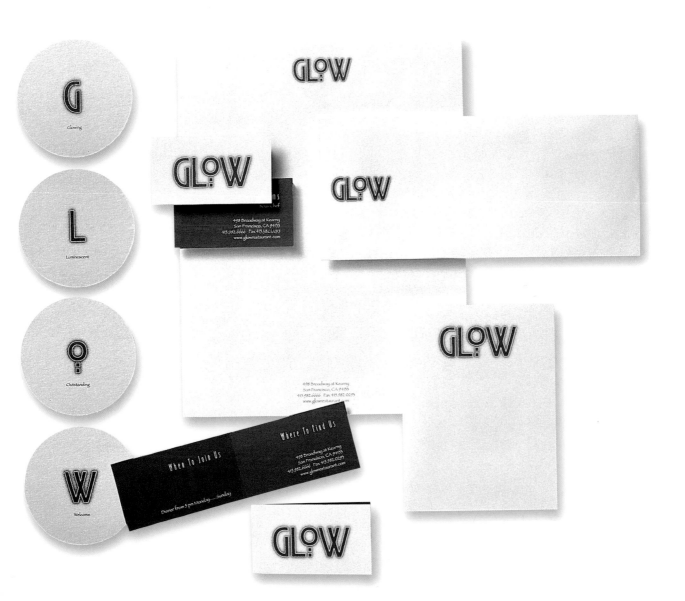

CHICAGO CUTLERY®

DESIGN FIRM	MLR Design
ART DIRECTOR/DESIGNER	Julie Wineski
CLIENT	World Kitchen
TOOLS	Adobe Illustrator 8.0, Macintosh

DESIGN FIRM	Lewis Moberly
ART DIRECTOR	Mary Lewis
DESIGNER	Joanne Smith
CLIENT	Finca Flichman
TOOL	Adobe Illustrator8.0, Macintosh

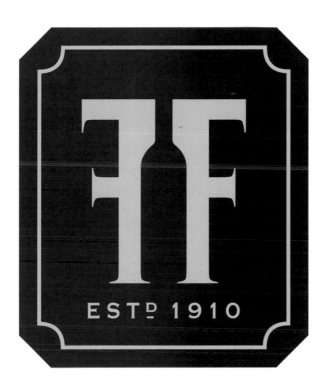

FINCA FLICHMAN

WINERY

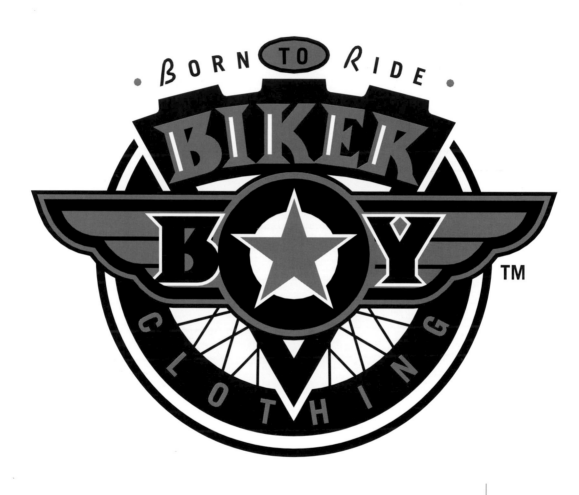

DESIGN FIRM	Sayles Graphic Design
ART DIRECTOR	John Sayles
DESIGNER	John Sayles
CLIENT	Sayles Graphic Design
TOOLS	Adobe Illustrator, Macintosh

DESIGN FIRM | Sayles Graphic Design
ART DIRECTOR | John Sayles
DESIGNER | John Sayles
CLIENT | Phil Goode Grocery
TOOLS | Adobe Illustrator, Macintosh

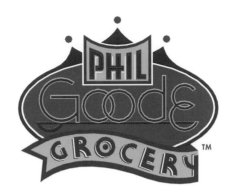

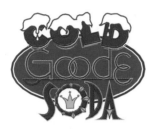

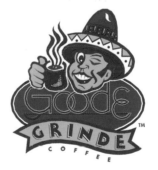

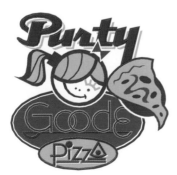

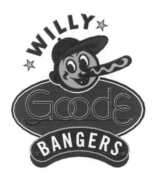

DESIGN FIRM	Sayles Graphic Design
ART DIRECTOR	John Sayles
DESIGNER	John Sayles
CLIENT	Jordan Motors
TOOLS	Adobe Illustrator, Macintosh

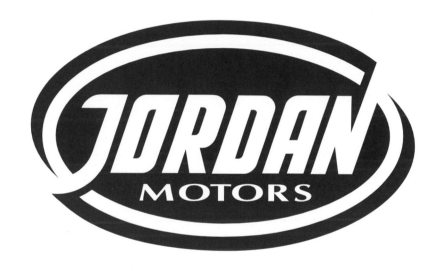

DESIGN FIRM	Sonsoles Llorens
ART DIRECTOR	Sonsoles Llorens
DESIGNER	Sonsoles Llorens
CLIENT	Storage/Marta Sanllehi, Javier Crosas
TOOLS	Macromedia FreeHand, Macintosh

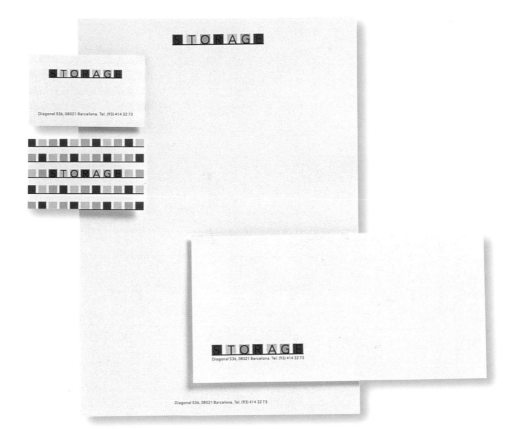

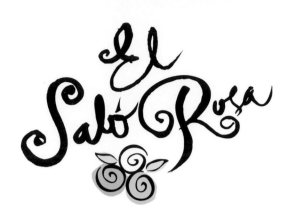

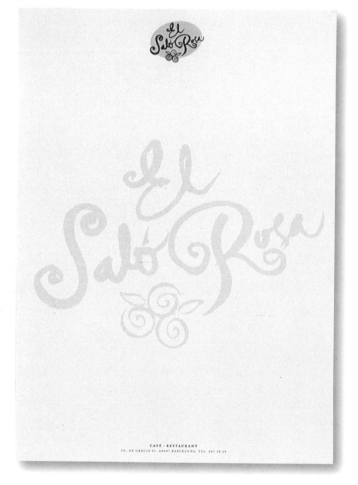

DESIGN FIRM	Sonsoles Llorens
ART DIRECTOR	Sonsoles Llorens
DESIGNER	Sonsoles Llorens
CLIENT	Publicentre S.A./Enric Vives, Chairman
TOOLS	Macromedia FreeHand, Adobe Photoshop, Streamline, Macintosh

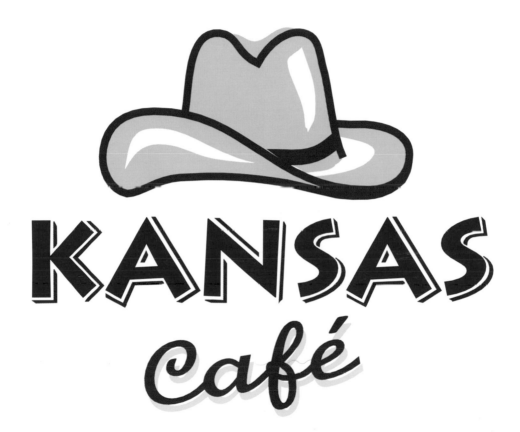

DESIGN FIRM | Sonsoles Llorens
ART DIRECTOR | Sonsoles Llorens
DESIGNER | Sonsoles Llorens
CLIENT | BCR/Kansas Café
TOOLS | Macromedia FreeHand, Macintosh

RECREATION AND ENTERTAINMENT

DESIGN FIRM	Anderson Thomas Design
ART DIRECTORS	Jay Smith, Joel Anderson
DESIGNER	Jay Smith
CLIENT	The Nashville Symphony
TOOLS	Adobe Illustrator, Macintosh

THE NASHVILLE SYMPHONY

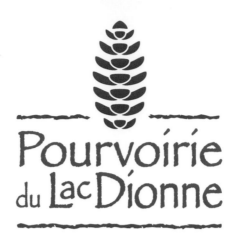

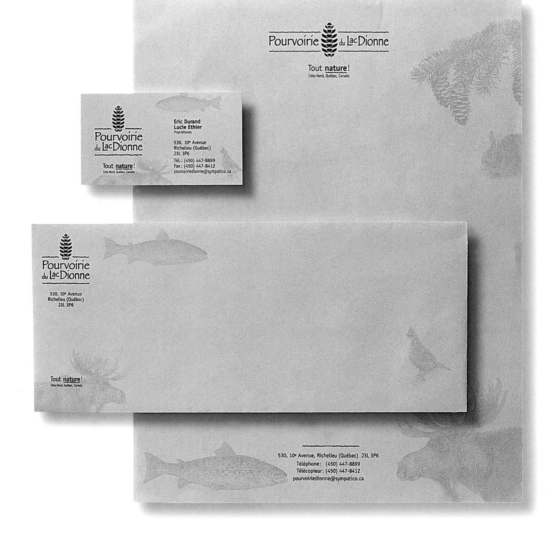

DESIGN FIRM | Beaulieu Concepts Graphiques, Inc.
ART DIRECTOR | Gilles Beaulieu
DESIGNER | Gilles Beaulieu
CLIENT | Pourvoirie du Lac Dionne
TOOLS | Adobe Photoshop, Adobe Illustrator, Macintosh

DESIGN FIRM	Blok Design, Inc.
ART DIRECTOR	Vanessa Eckstein
DESIGNERS	Vanessa Eckstein, Frances Chen
CLIENT	Rave Films
TOOL	Adobe Illustrator

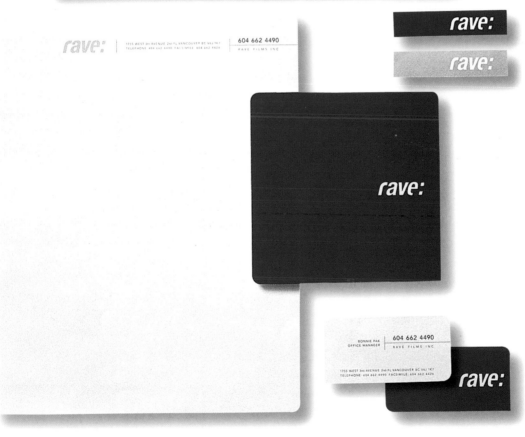

DESIGN FIRM	Christopher Gorz Design
ART DIRECTOR	Chris Gorz
DESIGNER	Chris Gorz
CLIENT	Up-All-Nite Records
TOOLS	Adobe Illustrator, Macintosh

DESIGN FIRM	Cato Partners
DESIGNER	Cato Partners
CLIENT	Melbourne International Festival of the Arts
TOOLS	Adobe Illustrator 6, Macintosh

WELLSPRING

DESIGN FIRM	Design Center
ART DIRECTOR	John Reger
DESIGNER	Sherwin Schwartzrock
CLIENT	Wellspring
TOOLS	Macromedia FreeHand, Macintosh

DESIGN FIRM	C.W.A., Inc.
ART DIRECTOR	Calvin Woo
DESIGNER	Marco Sipriaso
CLIENT	Asian-American Journalists Association/San Diego Asian Film Festival
TOOL	Adobe Illustrator 9

TRANQUILLITY

TRANQUILLITY

Larry Barnet Captain

Telephone 871 32 531 4910
Facsimile 871 32 531 4911

Telephone 871 32 531 4910 *Facsimile* 871 32 531 4911

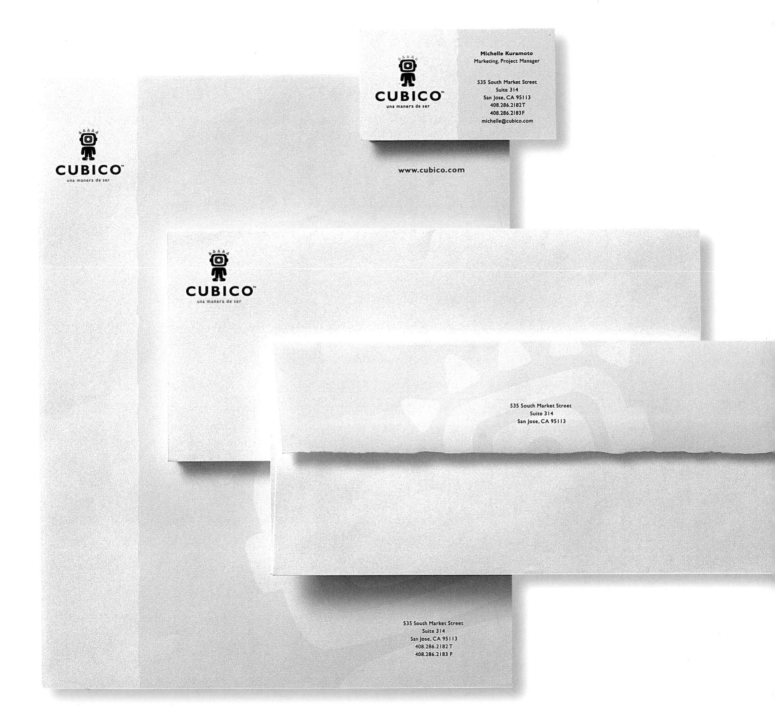

DESIGN FIRM | Duarte Design
ART DIRECTOR | Dave Zavala
DESIGNER | Dave Zavala
CLIENT | Cubico
TOOLS | Adobe Illustrator, Quark XPress,
Adobe Photoshop, Macintosh

DESIGN FIRM | Drive Communications
ART DIRECTOR | Michael Graziolo
DESIGNER | Michael Graziolo
CLIENT | Michael Bloomberg/Tranquility
TOOLS | Adobe Illustrator 8.0, Macintosh

DESIGN FIRM	Gardner Design
ART DIRECTORS	Travis Brown, Bill Gardner
DESIGNER	Travis Brown
CLIENT	The Oaks
TOOLS	Macromedia FreeHand, Adobe Photoshop

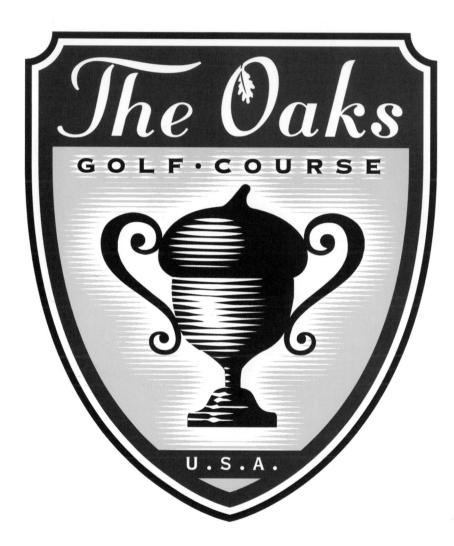

DESIGN FIRM | Gardner Design
ART DIRECTOR | Chris Parks
DESIGNER | Chris Parks
CLIENT | Red Devils Softball Team
TOOLS | Macromedia FreeHand, Adobe Photoshop

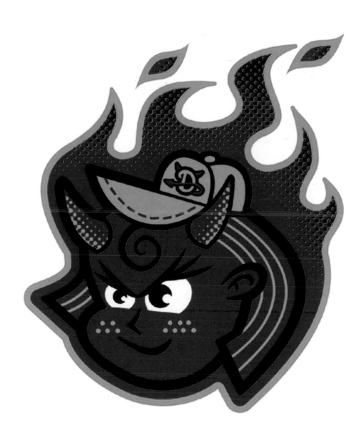

DESIGN FIRM	Gardner Design
ART DIRECTOR	Chris Parks
DESIGNER	Chris Parks
CLIENT	Dewy & The Big Dogs
TOOL	Macromedia FreeHand

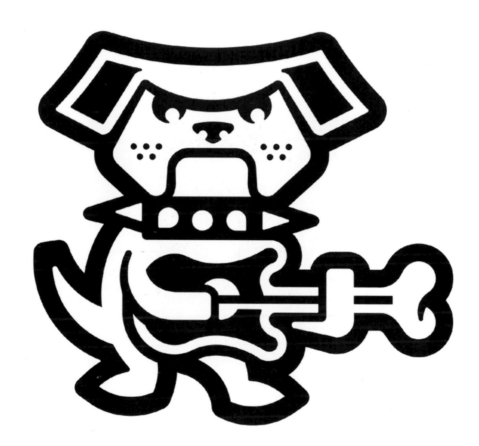

DESIGN FIRM	Hornall Anderson Design Works, Inc.
ART DIRECTOR	Jack Anderson
DESIGNERS	Jack Anderson, Andrew Smith,
	Mary Chin Hutchison, Taro Sakita
CLIENT	K2 Corporation/K2 Skis Mod Logo
TOOL	Adobe Photoshop

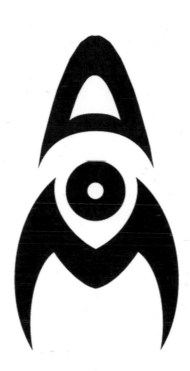

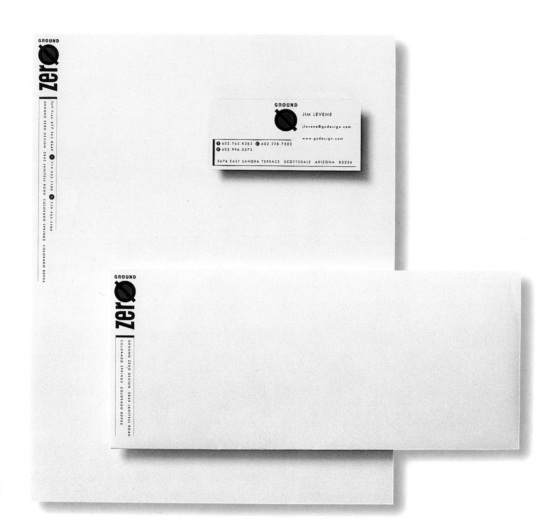

**RECREATION
AND
ENTERTAINMENT**

GROUND
zerø

DESIGN FIRM	Hornall Anderson Design Works, Inc.
ART DIRECTOR	Jack Anderson
DESIGNERS	Jack Anderson, Kathy Saito, Julie Lock, Ed Lee, Heidi Favour, Virginia Le, Sonja Max
CLIENT	Ground Zero
TOOL	Macromedia FreeHand

DESIGN FIRM	Hornall Anderson Design Works, Inc.
ART DIRECTOR	Jack Anderson
DESIGNERS	Jack Anderson, Belinda Bowling,
	Andrew Smith, Don Stayner
CLIENT	Streamworks
TOOL	Adobe Illustrator

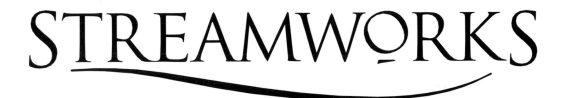

STREAMWORKS

STREAMWORKS

STREAMWORKS

NAME		TITLE		
Bob Caldwell		Chairman & President		
STREET	SUITE	CITY	STATE	ZIP CODE
1500 Westlake Ave. N.	118	Seattle	WA	98109-3036
PHONE	FAX		TOLL FREE	
206.301.9292	206.376.1438		800.611.0008	
EMAIL		INTERNET		
bobca@streamworks.org		www.streamworks.org		

STREAMWORKS

| PHONE | FAX | INTERNET | STREET | SUITE | CITY | STATE | ZIP CODE |
| 206.301.9292 | 206.376.1438 | www.streamworks.org | 1500 Westlake Ave N | 118 | Seattle | WA | 98109 |

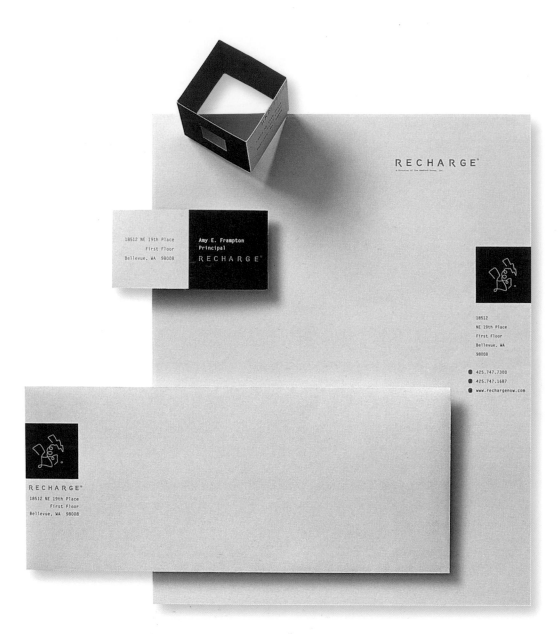

DESIGN FIRM	Hornall Anderson Design Works, Inc.
ART DIRECTOR	Jack Anderson
DESIGNERS	Jack Anderson, Katha Dalton, Henry Yiu,
	Tiffany Scheiblauer, Darlin Gray, Brad Sherman
CLIENT	Recharge
TOOL	Macromedia FreeHand

DESIGN FIRM | Insight Design Communications
ART DIRECTORS | Sherrie & Tracy Holdeman
DESIGNERS | Sherrie & Tracy Holdeman
CLIENT | 4Points Travel
TOOLS | Hand Drawn, Macromedia FreeHand 9.0.1

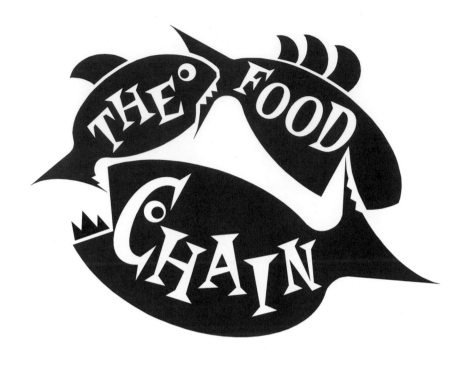

DESIGN FIRM	Jeff Fisher LogoMotives
ART DIRECTOR	Jeff Fisher
DESIGNER	Jeff Fisher
CLIENT	Triangle Productions!
TOOLS	Macromedia FreeHand, Macintosh

DESIGN FIRM	Lloyds Graphic Design & Communication
ART DIRECTOR	Alexander Lloyd
DESIGNER	Alexander Lloyd
CLIENT	Functions Unlimited
TOOLS	Macromedia FreeHand, Macintosh

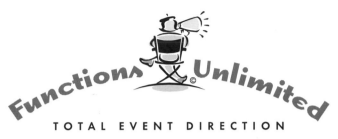

TOTAL EVENT DIRECTION

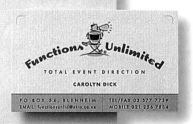

DESIGN FIRM	Michael Doret Graphic Design
ART DIRECTOR	Joel Hladecek
DESIGNER	Michael Doret
CLIENT	Red Sky Interactive
TOOL	Adobe Illustrator 8.01

DESIGN FIRM	Michael Doret Graphic Design
ART DIRECTOR	Michael Doret
DESIGNER	Michael Doret
CLIENT	Squirrel Nut Zippers
TOOL	Adobe Illustrator 8.01

DESIGN FIRM	Sayles Graphic Design
ART DIRECTOR	John Sayles
DESIGNER	John Sayles
CLIENT	Glazed Expressions
TOOLS	Adobe Illustrator, Macintosh

DESIGN FIRM	Sayles Graphic Design
ART DIRECTOR	John Sayles
DESIGNER	John Sayles
CLIENT	Pattee Enterprises
TOOL	Adobe Illustrator, Macintosh

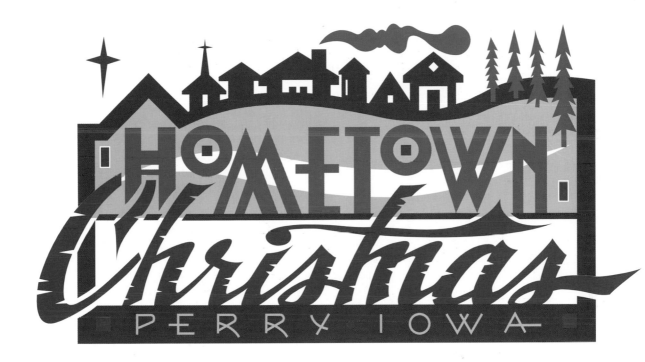

EDUCATION, HEALTH, AND NON-PROFIT

Dr Julie Plamondon
Dentiste

2081, Marie-Victorin
Varennes (Québec) J3X 1R3
Tél. : (450) **652-3363**

DESIGN FIRM	Beaulieu Concepts Graphiques, Inc.
ART DIRECTOR	Gilles Beaulieu
DESIGNER	Gilles Beaulieu
CLIENT	Dr. Julie Plamondon
TOOLS	Adobe Photoshop, Adobe Illustrator, Macintosh

2081, Marie-Victorin
Varennes (Québec) J3X 1R3

DESIGN FIRM	Bakker Design
ART DIRECTOR	Doug Bakker
DESIGNERS	Doug Bakker, Brian Sauer
CLIENT	Mentor Iowa
TOOLS	Macromedia FreeHand 9, Macintosh

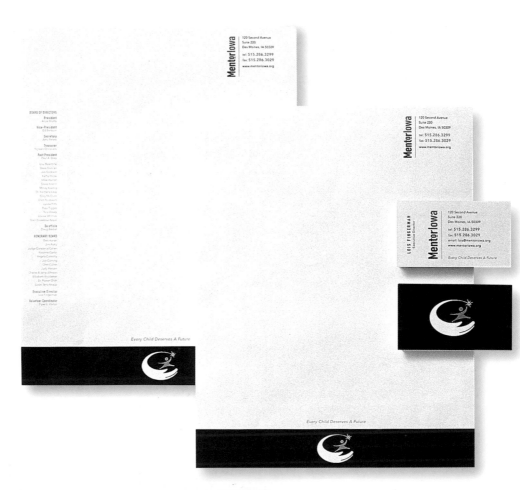

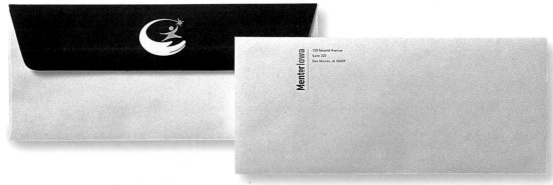

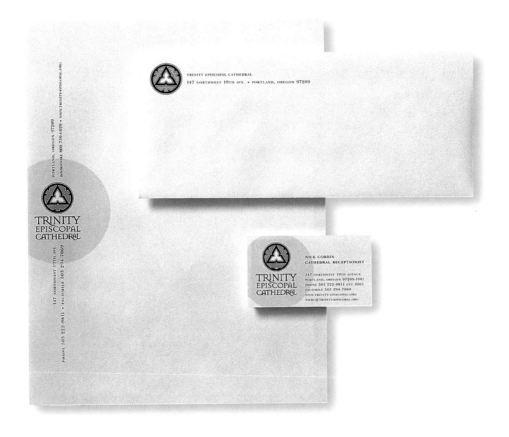

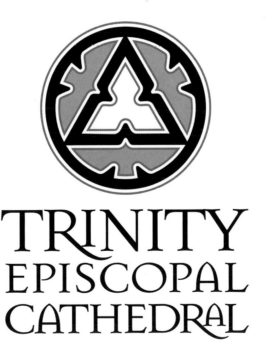

TRINITY
EPISCOPAL
CATHEDRAL

DESIGN FIRM	Bailey/Franklin
ART DIRECTOR	Connie Lightner
DESIGNER	Connie Lightner
CLIENT	Trinity Episcopal Cathedral
TOOLS	Quark XPress, Adobe Illustrator, Macintosh

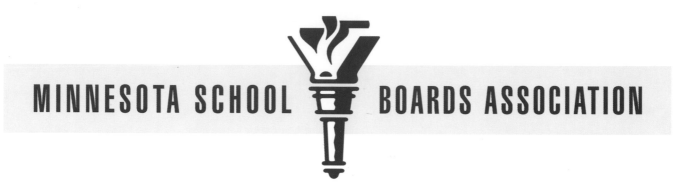

MINNESOTA SCHOOL BOARDS ASSOCIATION

DESIGN FIRM | Design Center
ART DIRECTOR | John Reger
DESIGNER | Sherwin Schwartzrock
CLIENT | Minnesota School Boards Association
TOOLS | Macromedia FreeHand, Macintosh

DESIGN FIRM | DogStar
ART DIRECTOR | Charles Black/Intermark Gillis
DESIGNER | Rodney Davidson
CLIENT | Watch Me Grow Learning Center
TOOL | Macromedia FreeHand 7

DESIGN FIRM | DogStar
DESIGNER | Rodney Davidson
CLIENT | Black Warrior–Cahaba River Land Trust
TOOL | Macromedia FreeHand 7

DESIGN FIRM	Hornall Anderson Design Works, Inc.
ART DIRECTORS	Jack Anderson, Lisa Cerveny
DESIGNERS	Lisa Cerveny, Jana Nishi, Bruce Branson-Meyer, Don Stayner, Mary Chin Hutchison, Jack Anderson
CLIENT	XOW!
TOOL	Macromedia FreeHand

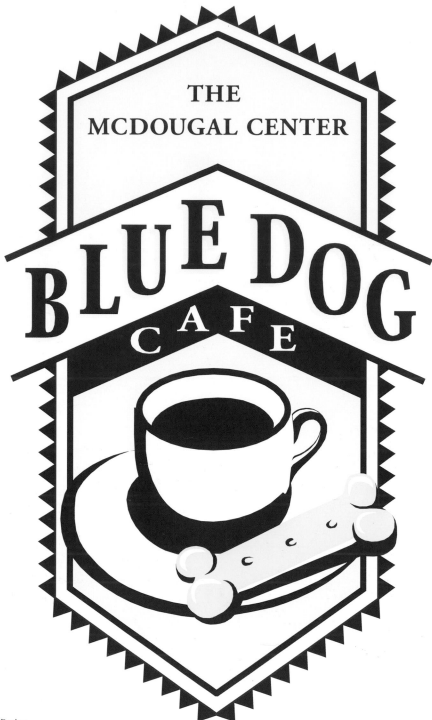

DESIGN FIRM	Icehouse Design
ART DIRECTOR	Bjorn Akselsen
DESIGNER	Bjorn Akselsen
CLIENT	Yale University's Blue Dog Café
TOOLS	Adobe Illustrator, Macintosh

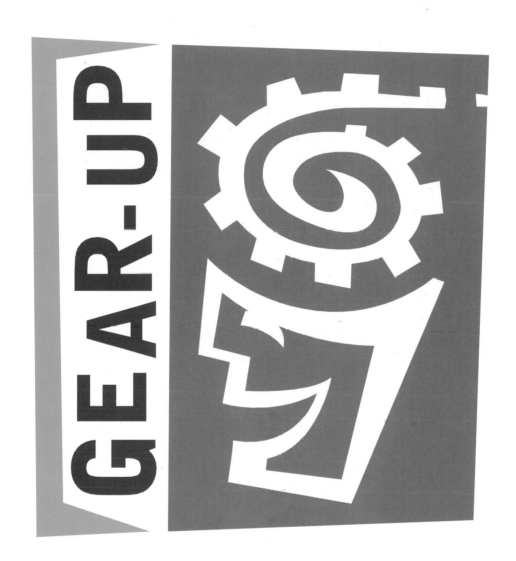

DESIGN FIRM	Insight Design Communications
ART DIRECTORS	Sherrie & Tracy Holdeman
DESIGNERS	Sherrie & Tracy Holdeman
CLIENT	Gear Up
TOOLS	Hand Drawn, Macromedia FreeHand 9.0.1

IN 8 水

Dr. Richard Visser

dr. Richard Visser - Havenstraat #30
Oranjestad, Aruba

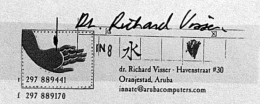

IN 8 水

Dr. Richard Visser

t 297 889441
f 297 889170

dr. Richard Visser - Havenstraat #30
Oranjestad, Aruba
innate@arubacomputers.com

ART DIRECTOR	Melanie Sherwood
DESIGNER	Melanie Sherwood
CLIENT	Unity Center of Positive Prayer
TOOLS	Adobe Illustrator, Macintosh

UNITY CENTER

A CHURCH OF POSITIVE PRAYER

DESIGN FIRM	Miriello Grafico
ART DIRECTOR	Chris Keeney
DESIGNER	Chris Keeney
CLIENT	Visser
TOOL	Adobe Illustrator

DESIGN FIRM	Stoltze Design
ART DIRECTOR	Clifford Stoltze
DESIGNERS	Lee Schulz, Cindy Patten, Brandon Blangger
CLIENT	Six Red Marbles
TOOLS	Macromedia FreeHand, Adobe Illustrator, Quark XPress, Macintosh

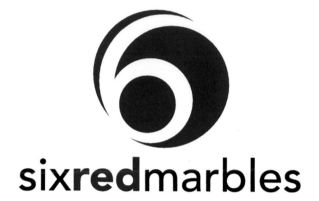

sixredmarbles

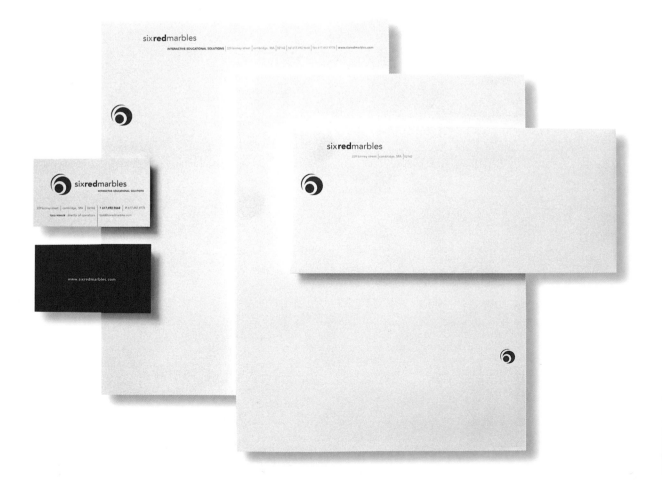

DESIGN FIRM	Sayles Graphic Design
ART DIRECTOR	John Sayles
DESIGNER	John Sayles
CLIENT	Advertising Professionals of Des Moines
TOOLS	Adobe Illustrator, Macintosh

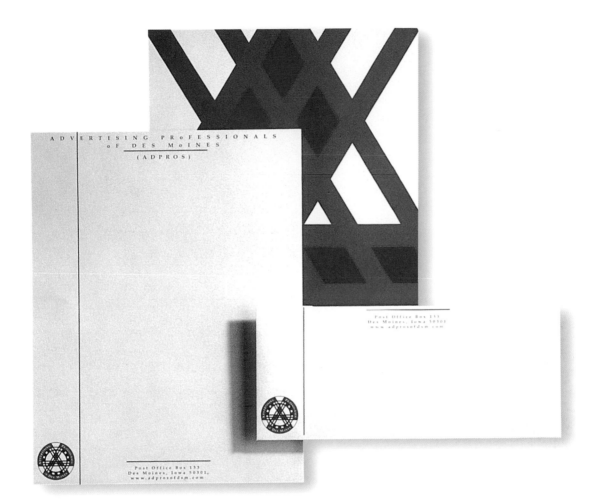

ADVERTISING PRoFESSIONALS
oF DES MoINES
(ADPROS)

Post Office Box 133
Des Moines, Iowa 50301,
www.adprosofdsm.com

Post Office Box 133
Des Moines, Iowa 50301
www.adprosofdsm.com

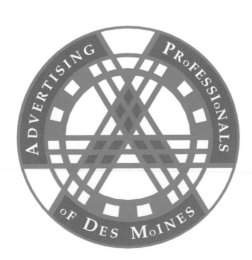

PRESIDENT
Edward P. Ryan Jr.
Fitchburg

PRESIDENT-ELECT
Carol A.G. DiMento
Swampscott

VICE PRESIDENT
Cynthia J. Cohen
Boston

VICE PRESIDENT
Janet Kenton-Walker
Boston

TREASURER
Joseph P.J. Vrabel
Framingham

SECRETARY
Richard P. Campbell
Boston

GENERAL COUNSEL
Martin W. Healy
Boston

20 West Street Boston, Massachusetts 02111-1218 TEL 617.338.0635 FAX 617.542.7947 WEB www.massbar.org

DESIGN FIRM	Stewart Monderer Design, Inc.
ART DIRECTOR	Stewart Monderer
DESIGNERS	Jeffrey Gobin, Stewart Monderer
CLIENT	Massachusetts Bar Association
TOOLS	Adobe Illustrator, Quark XPress, Macintosh

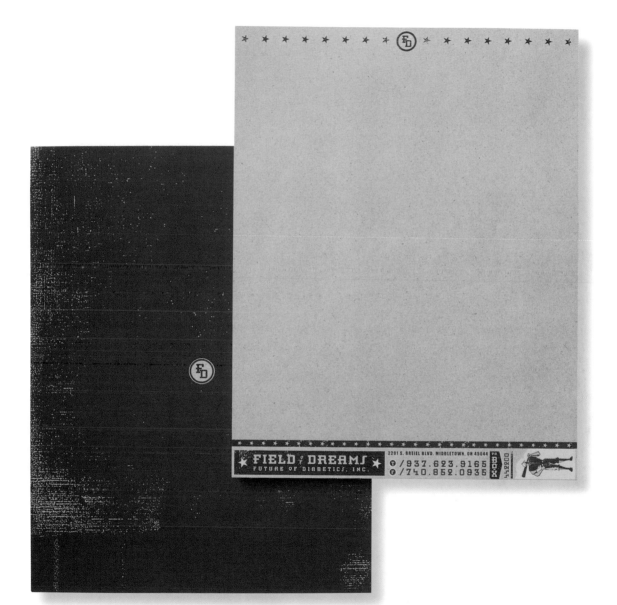

DESIGN FIRM | Visual Marketing Associates, Inc.
ART DIRECTORS | Kenneth Botts, Jason Selke
DESIGNER | Jason Selke
CLIENT | Future of Diabetics, Inc./ Field of Dreams
TOOLS | Macromedia FreeHand 8.0, Macintosh

MISCELLANEOUS

DESIGN FIRM	Anderson Thomas Design
ART DIRECTOR	Joel Anderson
DESIGNER	Ramay Lewis
CLIENT	Hardwear
TOOLS	Adobe Illustrator, Adobe Photoshop, Macintosh

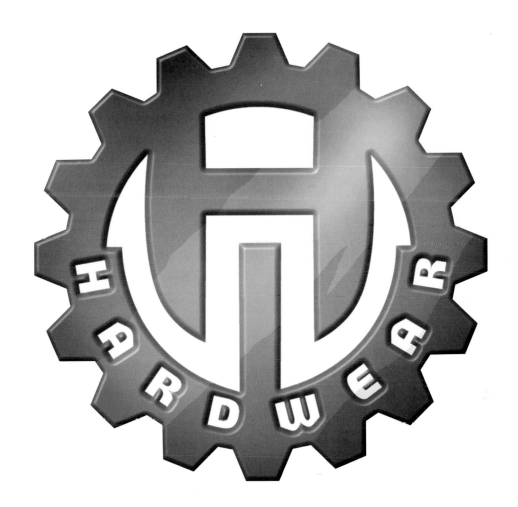

DESIGN FIRM	Buchanan Design
ART DIRECTOR	Bobby Buchanan
DESIGNERS	Armando Abundis, Bobby Buchanan
CLIENT	Hispanicvista.com
TOOLS	Adobe Illustrator, Macintosh

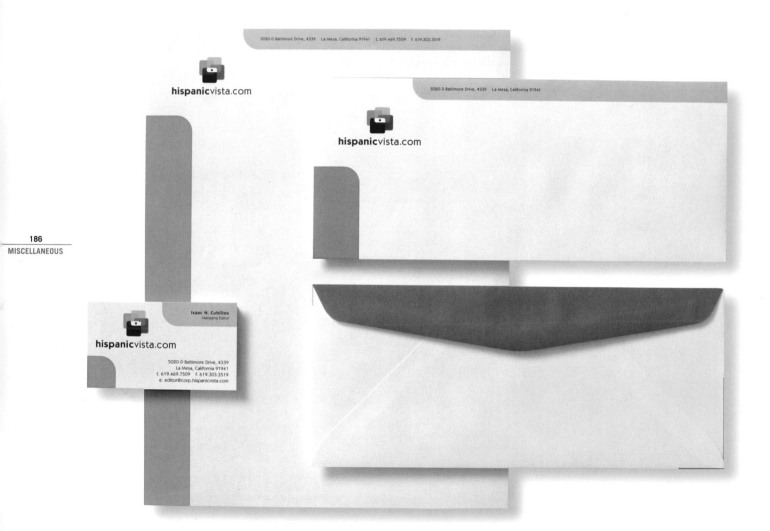

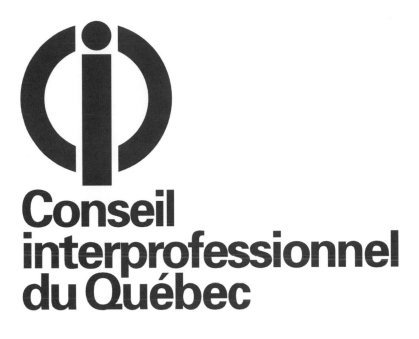

Conseil interprofessionnel du Québec

DESIGN FIRM	Beaulieu Concepts Graphiques, Inc.
ART DIRECTOR	Gilles Beaulieu
DESIGNER	Gilles Beaulieu
CLIENT	CIQ
TOOLS	Adobe Illustrator, Macintosh

mextile

DESIGN FIRM	cincodemayo
ART DIRECTOR	Mauricìo Alanis
DESIGNER	Mauricìo Alanis
CLIENT	Mextile
TOOLS	Macromedia FreeHand, Macintosh

DESIGN FIRM	Catalina Design Group
ART DIRECTOR	Elena Abee
DESIGNER	Elena Abee
CLIENT	D.R. Horton
TOOLS	Adobe Illustrator, Adobe Photoshop

Sombrosa

AT PASEO DEL SOL

DESIGN FIRM	Catalina Design Group
ART DIRECTOR	Elena Abee
DESIGNER	Elena Abee
CLIENT	Continental
TOOLS	Adobe Illustrator, Adobe Photoshop

DESIGN FIRM	Gee + Chung Design
ART DIRECTOR	Earl Gee
DESIGNERS	Earl Gee, Kay Wu
CLIENT	iAsiaWorks, Inc.
TOOLS	Adobe Illustrator, Quark XPress

[WORLDWIDE OPERATIONS]

[MISSION STATEMENT]

[STRATEGIC INITIATIVES]

[VALUES]

[ARCHITECTURAL DIRECTION]

[COMPONENTS]

DESIGN FIRM | Gee + Chung Design
ART DIRECTOR | Earl Gee
DESIGNERS | Earl Gee, Fani Chung
CLIENT | Sun Microsystems
TOOLS | Adobe Illustrator, Quark XPress

DESIGN FIRM	Gardner Design
ART DIRECTOR	Chris Parks
DESIGNER	Chris Parks
CLIENT	Blue Hat Media
TOOL	Macromedia FreeHand 8

bluehat

MEDIA · · · · ·

ARES

DESIGN FIRM	Gardner Design
ART DIRECTOR	Chris Parks
DESIGNER	Chris Parks
CLIENT	Ares
TOOL	Macromedia FreeHand

DESIGN FIRM	Gardner Design
ART DIRECTOR	Chris Parks
DESIGNER	Chris Parks
CLIENT	Prairie State Bank
TOOL	Macromedia FreeHand

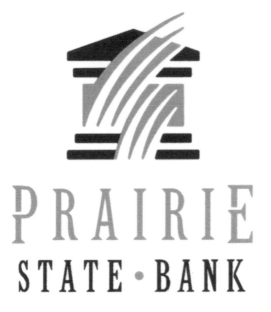

PRAIRIE

STATE · BANK

PRAIRIE
STATE · BANK

512 STATE STREET • AUGUSTA, KANSAS • 67010 0520

PRAIRIE
STATE · BANK

DAVE A. BISAGNO
VICE PRESIDENT

TELEPHONE 316 775 5434 • FACSIMILE 316 775 1790

PRAIRIE
STATE · BANK

512 STATE STREET • AUGUSTA, KANSAS • 67010 1168 • TELEPHONE 316 775 5434 • FACSIMILE 316 775 1790

OFFICES IN • AUGUSTA • ANDALE • GODDARD • HAYSVILLE • MAIZE • MULVANE • ROSE HILL • WICHITA

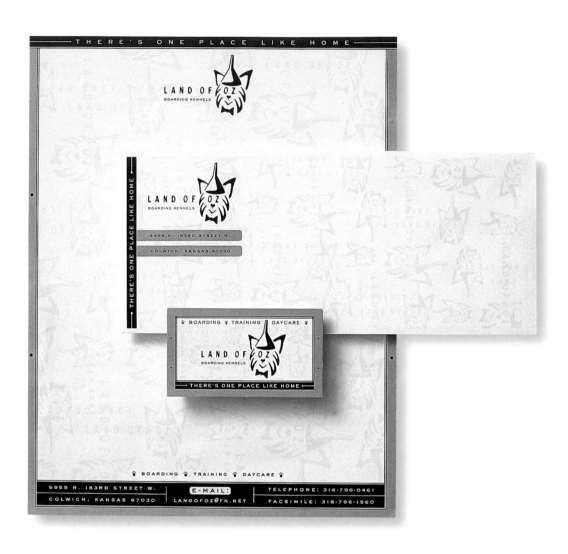

DESIGN FIRM | Gardner Design
ART DIRECTOR | Travis Brown
DESIGNER | Travis Brown
CLIENT | Land of Oz Kennels
TOOL | Macromedia FreeHand

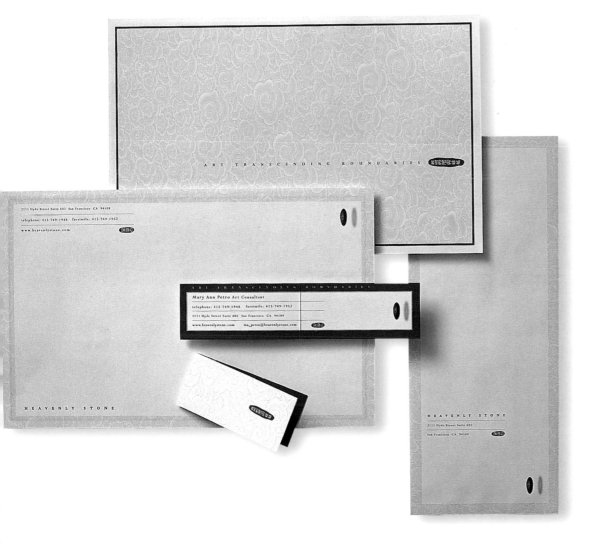

DESIGN FIRM	Hornall Anderson Design Works, Inc.
ART DIRECTOR	Jack Anderson
DESIGNERS	Jack Anderson, Henry Yiu, Taka Suzuki
CLIENT	Heavenly Stone
TOOL	Macromedia FreeHand

DESIGN FIRM	Insight Design Communications
ART DIRECTORS	Sherrie & Tracy Holdeman
DESIGNERS	Sherrie & Tracy Holdeman
CLIENT	eMeter
TOOL	Macromedia FreeHand 9.0.1

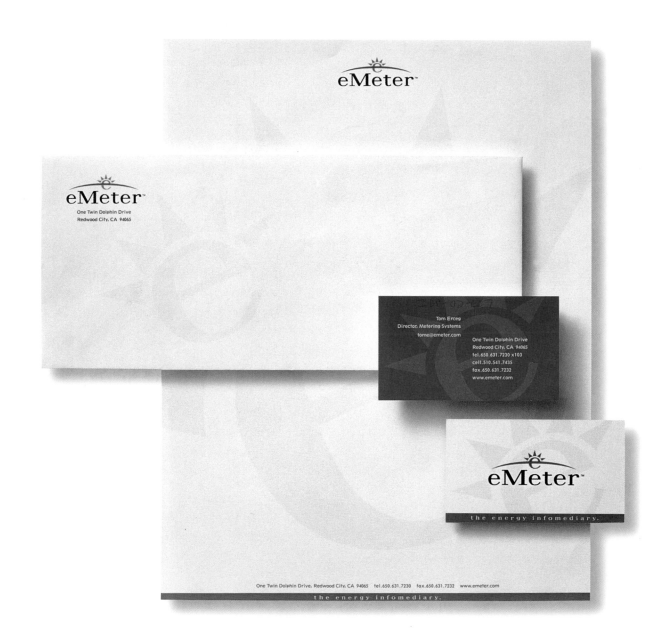

DESIGN FIRM	Insight Design Communications
ART DIRECTORS	Sherrie & Tracy Holdeman
DESIGNERS	Sherrie & Tracy Holdeman
CLIENT	Brad Bachman Homes, Inc.
TOOLS	Hand Drawn, Macromedia FreeHand 9.0.1

DESIGN FIRM Insight Design Communications
ART DIRECTORS Sherrie & Tracy Holdeman
DESIGNERS Sherrie & Tracy Holdeman
CLIENT Naples Remodeling
TOOLS Hand Drawn, Macromedia FreeHand 9.0.1

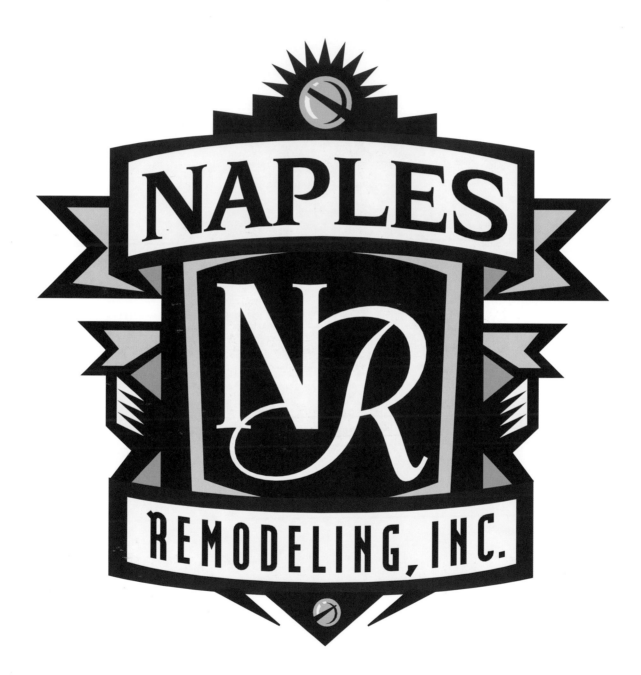

clearly canadian ®

DESIGN FIRM	Karacters Design Group
ART DIRECTOR	Maria Kennedy
DESIGNER	Matthew Clark
CLIENT	CC Beverage Corporation
TOOL	Adobe Illustrator

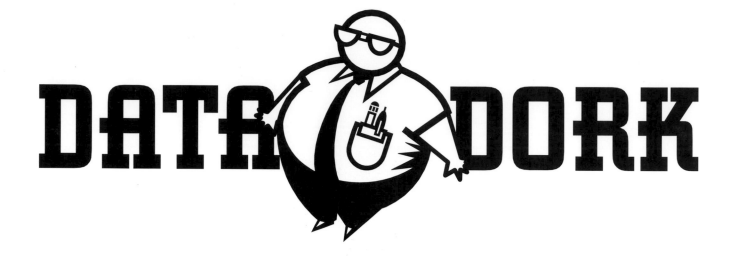

DESIGN FIRM	Jeff Fisher LogoMotives
ART DIRECTOR	Jeff Fisher
DESIGNER	Jeff Fisher
CLIENT	Datadork
TOOLS	Macromedia FreeHand, Macintosh

DESIGN FIRM	Miriello Grafico
ART DIRECTOR	Dennis Garcia
DESIGNER	Dennis Garcia
CLIENT	Technically Correct
TOOL	Adobe Illustrator

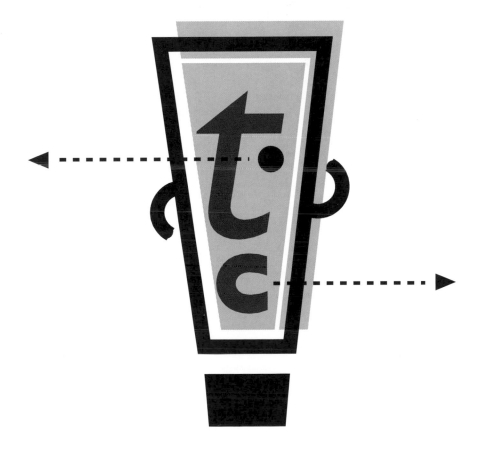

DESIGN FIRM	Sayles Graphic Design
ART DIRECTOR	John Sayles
DESIGNER	John Sayles
CLIENT	Sayles Graphic Design
TOOLS	Adobe Illustrator, Macintosh

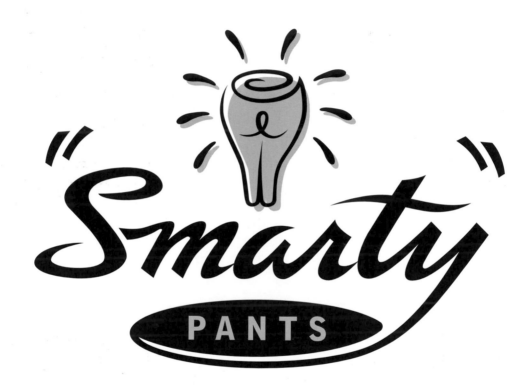

DESIGN FIRM	Sayles Graphic Design
ART DIRECTOR	John Sayles
DESIGNER	John Sayles
CLIENT	Sayles Graphic Design
TOOL	Adobe Illustrator, Macintosh

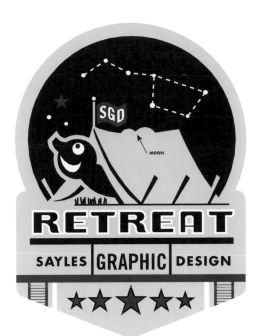

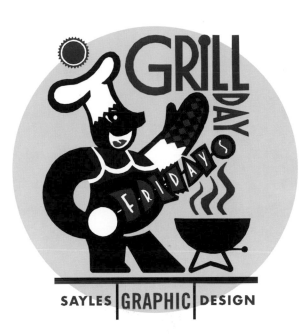

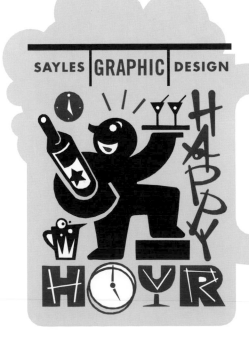

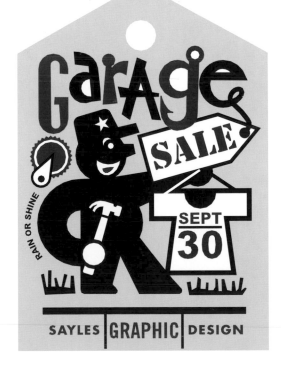

DIRECTORY

A1 Design
601 Minnesota Street, #120
San Francisco, CA 94107

Anderson Thomas Design
110 29th Avenue North, Suite 100
Nashville, TN 37203

art+corporate culture
A-1060 Wien
Esterhazyg.19
Austria

ARTiculation Group
33 Bloor Street East, Suite 1302
M4W 3T4
Toronto, Ontario
Canada

Bailey/Franklin
0121 SW Bancroft Street
Portland, OR 97201

Bakker Design
4507 98th Street
Urbandale, IA 50322

Base Art Co.
The Ripley House
623 High Street
Worthington, OH 43085

Beaulieu Concepts Graphiques, Inc.
38 Adelaide Avenue
Candiac, Quebec J5R 3J7
Canada

Becker Design
225 East Saint Paul Avenue, Suite 300
Milwaukee, WI 53202

Blok Design
398 Adelaide Street West, Suite 602
Toronto, Ontario M5V 2K4
Canada

Bruce Yelaska Design
1546 Grant Avenue
San Francisco, CA 94133

Buchanan Design
1035 F Street
San Diego, CA 92101

Bullet Communications, Inc.
200 South Midland Avenue
Joliet, IL 60436

Catalina Design Group
8911 Complex Drive, Suite F
San Diego, CA 92123

Cato Partners PTY Limited
254 Swan Street
Richmond 3121
Australia

Christopher Gorz Design
1122 Cambridge Drive
Grayslake, IL 60030

cincodemayo
5 de Mayo #1058 pte.
Monterrey, NL
Mexico 64000

Collider, Inc.
133 West 19th Street
New York City, NY 10011

C.W.A., Inc.
4015 Ibis Street
San Diego, CA 92103

D4 Creative Group
161 Leverington Avenue, Suite 1001
Philadelphia, PA 19127-2034

Design Center
15119 Minnetonka Boulevard
Mound, MN 55364

DGWB
217 North Main Street, #200
Santa Ana, CA 92701

Di Luzio D.G. & Comunicación
Terrero 2981
San Isidro
Argentina

DogStar
626 54th Street South
Birmingham, AL 35203

Drive Communications
133 West 19th Street
New York City, NY 10011

Duarte Design
809 Cuesta Drive, Suite 210
Mountain View, CA 94040

Dynamo Design
5 Upper Ormond Quay
Dublin
Ireland

D Zone Studio
273 West 7th Street
San Pedro, CA 90731

Energy Energy Design
246 Blossom Hill Road
Los Gatos, CA 95032

e-xentric (UK) Ltd
135 Park Street
London - SE1 9EA
UK

Fuel Creative
23 College Street
Greenville, SC 29601

Gardner Design
3204 East Douglas
Wichita, KS 67208

Gee + Chung Design
38 Bryant Street, Suite 100
San Francisco, CA 94105

Graphiculture
322 1st Avenue North, #304
Minneapolis, MN 55401

Halleck
700 Welch Road, #310
Palo Alto, CA 94304

Hornall Anderson Design Works, Inc.
1008 Western Avenue, Suite 600
Seattle, WA 98104

I. Paris Design
246 Gates Avenue
Brooklyn, NY 11238

Icehouse Design
266 West Rock Avenue
New Haven, CT 06515

Insight Design Communications
322 South Mosley
Wichita, KS 67202

Jay Smith Design
4709 Idaho Avenue
Nashville, TN 37209

Jeff Fisher LogoMotives
P.O. Box 17155
Portland, OR 97217-0155

KAISERDICKEN
149 Cherry Street
Burlington, VT 05401

Karacters Design Group
1500-777 Hornby Street
Vancouver, BC V6Z 2T3
Canada

Kiku Obata & Company
6161 Delmar Boulevard, Suite 200
St. Louis, MO 63112

Lebowitz/Gould/Design, Inc.
114 East 25th Street, Floor 7
New York City, NY 10010

Lewis Moberly
33 Gresse Street
London W1P 2LP
UK

Likovni Studio D.O.O.
Kerestinec, HR-10431
SV. Nedelja
Croatia

Lloyds Graphic Design & Communication
35 Dillon Street
Blenheim
New Zealand

Louey/Rubino Design Group, Inc.
2525 Main Street, Suite 204
Santa Monica, CA 90405

Love Communications
533 South 700 East
Salt Lake City, UT 84102

Mastandrea Design, Inc.
12711 Ventura Blvd., Suite 315
Studio City, CA 91604

Melanie Sherwood
1700 Newning Avenue
Austin, TX 78704

Michael Doret Graphic Design
6545 Cahuenga Terrace
Hollywood, CA 90068

Miriello Grafico
419 West G Street
San Diego, CA 92101

MLR Design
325 West Huron, Suite 812
Chicago, IL 60625

Nassar Design
11 Park Street, #1
Brookline, MA 02446

Nesnadny + Schwartz
10803 Magnolia Drive
Cleveland, OH 44106

Oakley Design Studios
921 SW Morrison, Suite 540
Portland, OR 97205

Oliver Russell & Associates
202 North 9th Street
Boise, ID 83702

Palmquist Creative
P.O. Box 325
Bozeman, MT 59771

PM Design
62 Robbins Avenue
Berkeley Heights, NJ 07922

Punkt
58 Gansevoort Street
New York, NY 10014

PXL8R Visual Communications
P.O. Box 7678
Van Nuys, CA 91409

R2 Design
Praceta D. Nuno Álvares Pereira, 20 · 5° FQ
4450 218 Matosinhos
Portugal

Refinery Design Company
2001 Alta Vista Street
Dubuque, IA 52001-4339

Sayles Graphic Design
3701 Beaver Avenue
Des Moines, IA 50310

Second Floor
443 Folsom Street
San Francisco, CA 94105

Shamlian Advertising
10 East Sproul Road
Springfield, PA 19064

Sonsoles Llorens Graphic Design
Caspe 56
Barcelona 08010
Spain

Stewart Monderer Design, Inc.
10 Thacher Street, Suite 112
Boston, MA 02113

Stoltze Design
49 Melcher Street
Boston, MA 02210

The Riordon Design Group
131 George Street
Oakville, Ontario L6J 3B9
Canada

Total Creative
9107 Wilshire Boulevard
Beverly Hills, CA 90210

Visual Marketing Associates, Inc.
123 Webster Street, Studio 3
Dayton, OH 45402

WorldSTAR Design & Communications
4401 Shallowford Road, Suite 192
PMB 552
Roswell, GA 30075

INDEX